# 花的世界
## 無限可能
### Chances to Possibilities

萬里機構

# 我的押花世界
## My World of Pressed Flower

　　第一次接觸押花，不自覺地就愛上了。與大自然的接近，與花建立的感情，彷似人與人之間的關係，更自然、更密切。

　　從押花到麗乾花、花裝置、夢想花及押花如何預防認知障礙症、2015年開始獲得國際獎、2017年開始舉辦個人展覽會，而我的作品做了很多慈善拍賣，以及在不同的社福機構、學校教學及擔任藝術顧問。期間最難忘的是2020年我能夠在美國費城年度花展押花項目中得到冠軍。心情實在激動。押花給予我的力量及啟示，非筆墨可以形容。我個人希望這項藝術可從五個方面發展：

### 1) 親子藝術教育

　　香港的小學，大部分推行一人一音樂藝術學習、或一人一運動培訓，而選擇音樂藝術，基本也是集中傳統的樂理及音樂和演奏等等，能把這項押花藝術引入學校，小朋友可學習創意藝術，而且可以灌輸有關大自然及環保的通識教育給他們。

### 2) 長者藝術教育

　　長者朋友做出非常傑出的作品，每次都可以得到很大的認定，並且可以定期舉行展覽會，在家人和朋友之間更肯定自己的自我價值。

### 3) 啟發展能人士藝術興趣

　　鼓勵展能朋友一起創作押花，希望可以衝出國際，得到一個認定的水平。

### 4) 鼓勵年青人藝術創作

　　鼓勵年青人，藉此啟發他們對創作藝術的興趣，亦可以認識新朋友，一舉兩得。

### 5) 推廣關注環保生態

　　正如李樂詩博士說：「我們也許曾浪費了一些花朵和植物，最理想是在他們最美麗的時候保存下來，做成押花作品。也提醒大家珍惜大自然、愛護這個地球，瀕臨絕種的動物或罕有的植物亦可以延續生命，人類生活就會更加健康。」

　　在我的押花世界裏，可以發揮創意藝術、擁有不可言喻的滿足感。明天的自己從今天開始──花的世界無限可能。

It was 5 years ago when I attended my first pressed flowers lesson. I was impressed by the technique of pressed flowers and my inspiration towards this art. It was a process of plants re-born and natural beauty with this art. Over the years, I was fortunate to have the opportunities to display my work in America , Japan and Hong Kong. I went to the Philadelphia Flower Show in Feb 2020 and surprisingly found that I was awarded the first prize winner of the pressed flower session - Lunch in a Piazza: I love Paris. I am proud of having this honor and would like to share my knowledge of this art to the people of Hong Kong and around the globe. Here are five main theme of my pressed flower art creation:

### 1) Good Parenting Starts with Pressed Flower Workshop

Through participating in the courses children can learn more about the environment. The creation process enables the children to express themselves with their creative pressed flower art and is also a good chance to communicate with parents through the parent-child workshop.

### 2) Pressed Flower Course to Prevent Dementia

I taught elderly students of NGO's and helped them to hold exhibitions in public areas like MTR. Their joy and satisfaction towards their artwork gives them the motivation to carry on with their daily lives and helps to get rid of sickness such as Dementia.

### 3) Rehabilitation Workshop

The work of Rehab students was amazing and they had good communication with their families during the workshop. They achieved their work in the workshop and expressed themselves by their design of the work.

### 4) Encouraging Youth Creativity

The Samurai warriors practiced pressed flower art in the 16th century for enhancing their power of concentration and promoting patience and harmony with nature. This is a good model for teenagers to try Oshibana for stress relieving and development of creative thinking.

### 5) Environmental Awareness

Dr Lee Lok-Sze contributed her whole life in environment education and polar foundation. The collaboration of my pressed flower art and her photos of polar animals inspires me to create my art for awareness of global warming and pollution in nature.

The Magic of Pressed Flower
"It is beautiful. It is real. Love the nature. Life is new."

## 花藝學者　夏妙然博士
### Dr. Serina Ha Miu Yin

香港大學現代語言及文化學院日本研究博士、浸會大學傳理學文學及傳媒管理社會科學雙碩士、資深傳媒人，曾獲得 20 個國際廣播獎，為各大學學術嘉賓、講師及中國日報年度校園學報（中港澳台）新聞獎評委。學術研究包括有日本文化中介人對 80 年代香港流行文化之影響。

夏妙然博士是資深創意傳媒人，在香港大學主修日本研究，並於日本研修日本押花藝術五年，是日本全國押花藝術協會押花、麗乾花、夢想花導師。夏博士亦是日本草月流草月四級證會員，日本和裝教育協會和服二級講師及裏千家淡交會香港協會會員。

夏博士於 2015-2020 期間分別在日本大阪、東京、美國費城及香港展出其押花作品，於 2015 年獲韓國高陽市市長頒授年度花展「押花大賽榮譽獎」，2017年獲美國費城年度花展押花作品「報道榮譽獎」及日本東京年度大賽及 2017 年12 月年度麗乾花大賽「佳作榮譽獎」。夏博士為香港恆生大學藝術顧問，在香港大學、香港浸會大學、香港恆生大學、香港城市大學、香港鄧麗君歌迷會、陳百強國際歌迷會、明愛第三齡服務支援網路、勵智協進會、香港聖公會福利協會彩齡學院 、新生精神康復會、元崗幼稚園等擔任押花導師，並與眾機構合作在不同的港鐵站舉行師生押花展覽。夏博士押花作品亦曾進行慈善拍賣捐助慈善團體，2017 年為勵智協進會籌款；2019 年 9 月成為莫文蔚母親慈善基金（莫里士愛心行動基金）Morris Charity Foundation 全場拍賣會其中最受歡迎的作品之一。未來預計安排慈善收益捐贈極地博物館基金。

夏博士在 2018 年 3 月獲皇家亞洲文會北中國支會（上海）邀請，於有 100年歷史的上海外灘羅斯福公館擔任客席講師，是首位於館內舉行日本押花交流及展出作品的藝術家。並在 2017、2018 在香港大學、香港韓國文化院及香港恒生大學舉行個人展覽。2020 年成為美國婦女地質學會會員，同時憑作品 《廣場裏的午餐──我愛巴黎》（本書第 2 章）獲得美國費城第 191 屆花展押花組別冠軍榮譽。

Dr. Serina Ha Miu Yin holds a Ph.D. in Japanese Studies from the School of Modern Languages and Cultures at the University of Hong Kong. Her research thesis focuses on the impact of Cultural Intermediates in importing Japanese culture to Hong Kong in the 1980's. Having graduated MA in Communication and MSocSc in Media Management in the Hong Kong Baptist University, Ms. Ha is also an expert in the Media and Creative industry. She has won 20 international awards in past years, including awards such as the Beijing People Broadcasting "Win by Creativity", New York Festival and ABU Prize. She is also the adjudicator of the Campus Newspaper Awards held by China Daily since 2017.

She is an accomplished Japanese Botanic Artist, as well as a Pressed Flower and L'écrin Instructor of the Japan Fushigina Pressed Flower Association. Dr Ha had obtained level 4 of Sogetsu Foundation; Level 2 Kimono Instructor of Japanese Kimono Education Association and member of Japan Urasenke Foundation in HK.

Her art was first recognized at the 9th World Pressed Flower Craft Exhibition in Goyang Korea back in 2015 and her works have been widely exhibited in Osaka, Tokyo, Philadelphia and Hong Kong over the years. Dr. Ha has held an exhibition of her work at HKU in March 2017, as well as in Hang Seng University of Hong Kong and the Korean Culture Centre in 2018. Dr. Ha was invited as a Guest Speaker by Royal Asiatic Society Shanghai in March 2018. She was the first artist to hold Japanese pressed flower workshops at the House of Roosevelt of the Bund in Shanghai..Dr Ha recently joined the Woman Geographic Association of Washington as a member in 2020 .

She recently won the 1st Prize Award in the Philadelphia Flower Show 2020 after receiving the Honourable Mention Award in 2017. She has also been awarded the Best Art Award in L'écrin Flower Competition in Tokyo in 2017 and 2018. Her art has been acknowledged and helped raise fundings for the Intellectually Disabled Education and Advocacy League, and for the Morris Charity Initiative. In the future she hopes to raise a charity donation for the Polar Museum Foundation.

在香港大學主修日本研究的夏妙然博士，於日本研修日本押花藝術，為日本押花藝術協會導師，包括：

1）日本押花
2）日本麗乾花
3）日本麗乾花（花裝置）
4）日本自然印染
5）日本夢想花
6）日本花裝置（永恆保存）
7）日本押花預防認知障礙症

Dr Ha had obtained certificates in Japan :

1）Pressed Flower Instructor　押し花 インストラクター
2）L'écrin Flower Instructor (Bourgeon)
　　レカンフラワーブルジョン インストラクター
3）Floraison Instructor (Floration)
　　レカンフラワーフロレゾン インストラクター
4）Nature Print Instructor ネイチャープリント インストラクター
5）Dream Flower Instructor トリムフラワー インストラクター
6）Floraison Instructor (Ever Arrangement)
　　エバーアレンジメト　インストラクター
7）Pressed Flower Instructor (Dementia Prevention)
　　"花と暮らす認知症予防" 押し花インストラクター

## 國際獎：

1）2015　韓國第九屆高陽市年度花展押花大賽榮譽獎（羊年吉慶）
2）2017　美國費城年度花展押花報道榮譽獎（歡欣難年）
3）2017　日本麗乾花大賽作品賞（歡喜）
4）2017　日本麗乾花大賽佳作榮譽獎（永遠的夏）
5）2018　日本麗乾花大賽佳作榮譽獎（大自然之迴響）
6）2020　美國費城第 191 屆花展押花組冠軍（廣場裏的午餐──我愛巴黎）

## 作品概覽：

| | | |
|---|---|---|
| 2014-2019 | | 美國費城年度花展 |
| 2015 | 4/2015 | 日本大阪展覽會 |
| | 4/2015 | 韓國高陽花展 |
| 2017 | 17-27/3 | 香港大學逸夫教學樓（個人作品展） |
| | 4/2017 | 日本大阪展覽會 |
| | 23/6 | 慈善拍賣展出及作品捐助（勵智協進會） |
| | 1-31/12 | 港鐵展覽會 |
| | 20-22/12 | 日本東京麗乾花大賽作品展覽 |
| 2018 | 10-30/4 | 香港恒生大學 （日本押花藝術──個人作品展） |
| | 1-31/7 | 香港恒生大學學員作品港鐵（長沙灣站）展覽 |
| | 1-30/9 | 荃灣明愛第三齡服務支援網路押花工作坊學員作品港鐵荃灣站展覽 |
| | 7-28/12 | 香港韓國文化院（個人作品展） |
| 2019 | 1-31/3 | 香港聖公會工作坊學員作品海洋公園港鐵展覽 |
| | 30/3-3/4 | 日本大阪展覽會 |
| | 1-30/9 | 新生精神康復會學員作品奧運港鐵站展覽 |
| | 1/9 | 慈善拍賣展出及作品捐助（莫文蔚家族──莫理士愛心行動基金） |
| | 20-22/12 | 東京展覽──支持奧運參予作品展 |
| 2020 | 29/2-8/3 | 美國費城第 191 屆花展 |

## 榮譽：
## Achievements:

日本駐港總領事館／香港日本人文化協會──日本語研修表揚獎（2014）
Consulate General of Japan in Hong Kong / HK Japan Society - Honorable Award of Japanese Language Learning
在香港人日本人總領事舘／香港日本人文化協會──日本語研修表彰狀

裏千家淡交會香港協會會員（2016）
Member of Japan Urasenke Foundation HK

香港大學現代語言及文化學院──日本研究博士（2016）
The University of Hong Kong - Ph.D. in Japanese Studies from the School of Modern Languages and Cultures

日本草月流草月四級證（2019）
Japan Sogetsu Foundation - Sogetsu Level 4 Member 草月会──草月四級修業

日本和裝教育協會──和服二級講師（2020）
Japan Kimono Education Association - Kimono Level 2 Instructor
日本和装教育協会きもの二級の講師

# 序
# Preface

I would like to express my deepest gratitude to all of my friends
Thank you for being there to support me over the years

Here is my collection of pressed flower art for all of you

賞花會友
My art for you

（第 14 章——你是我的明燈、照亮我的人生）
(Chapter 14 - You light up my Life)

# 前言

　　押花藝術可以是人們的手工藝，可以給工作忙碌的朋友作為減壓工具，可以給小朋友學習藝術的機會，可以給婦女們發掘自己創意的機會，可以讓不同族裔的朋友進行文化交流，可以給展能及復康朋友們重建自己的自信及重整未來。

　　我要多謝多年來給我鼓勵的長輩鍾景輝博士、李樂詩博士及鄭國江老師、日本世界押花藝術協会會長杉野宣雄先生、佐佐木老師，還有寫序給我的香港大學李焯芬教授、香港恒生大學方梓勳教授、香港浸會大學黃煜教授、香港出版總會會長李家駒博士、陳美齡博士、劉德華博士、高世章、周慧敏、香港日本人商工会議所事務局長柳生政一、駐香港韓國文化院院長朴宗澤及陳曉東，當然我要多謝和我一起合作做這本書的團隊！

　　在我香港大學的博士論文中，我研究日本文化中介人對 80 年代香港流行文化之影響時，根據相關內容我創立了「4D」理論，而在我押花的過程中亦存在這個理論：

第一個　D-Discovery 發現──從一幅作品的構思，到我如何發現新的內容去設計；

第二個　D-Decision making 決策──從而決定取材；

第三個　D-Directory 導向──意念的方向；

第四個　D-Diffusion of culture 文化感染──最後決定受眾的朋友。

　　在這本書第 15 章，我會教大家簡易的押花製作、可在家中自己 DIY 製作、做出一個簡單的押花賀卡，書籤及筷子套。

　　希望大家面對逆境時能自強不息，這本書為你帶來正能量。

## 目錄
## Table of Contents

花
的
世
界
無
限
可
能

媽媽：

這些年來
我不斷研修
學習押花
期間遇到任何事
你總是在我身邊
給我無限的鼓勵
我送給你的押花作品
你總放在最顯眼的位置
你對生活的積極態度
已成為我每天的力量
媽媽
永遠愛你
這本書送給你

妙
2020 年 6 月

# 押花世界　無限可能
## My World of Pressed Flower - Chances to Possibilities

　　押花藝術取材大自然的元素，將花朵、花瓣、葉子和其他有機材料，經過各種壓製技術，製成乾燥和平面的材料，以創作完整的圖畫。中國和日本一直沿用這種工藝，據說早在 16 世紀，日本武士以研修押花藝術，作為提高集中力、耐力及促進人與大自然和諧共處的學習。摩納哥嘉麗絲王妃曾習押花藝術，協助推廣押花藝術至世界各地。

　　Pressed flower craft is the art of using pressed flower and botanical materials to create an entire picture from these natural elements. Flowers, petals, leaves and other organic materials are being pressed until dry and flat, using a variety of pressing techniques. This craft has long been practiced as an art form in China and in Japan, where it is known as Oshibana ( 押し花 ). As early as the 16th century, Samurai warriors were said to have studied the art of Oshibana as a means of enhancing their powers of concentration, and of promoting patience and harmony with nature. Princess Grace Kelly of Monaco also practiced Oshibana and helped promote the art of pressed flower worldwide.

# 1

## 瘦弱的北極熊——全球暖化下的警告！
### Skinny Polar Bear - Awareness of Global Warming

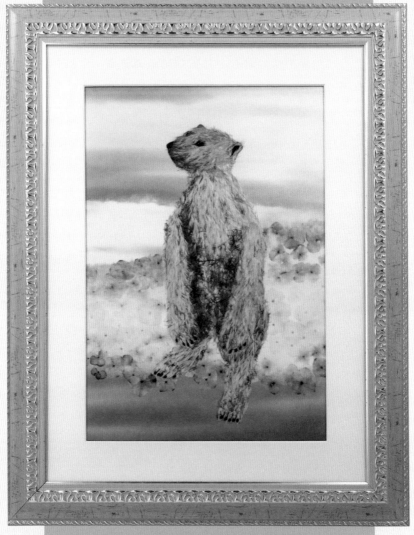

瘦せたホッキョクグマ（北極熊）- 地球温暖化の警告！

마른 북극곰 - 지구 온난화의 경고！

Ours polaire maigre - l'avertissement du réchauffement climatique!

Der dünn polarbär - Warnung vor Erderwärmung!

------------------------------ 花材 **Materials** ------------------------------

| 蒲葦 | 黃櫨 | 繡球花 |
|------|------|--------|
| Pampas Grass | Smoke Tree | Hydrangea |
| パンパスグラス | スモークツリー | アジサイ |
| 팜파스 그래스 | 안개나무 | 수국 |
| Herbe de Pampa | Arbre de fumée | Hortensia |
| Pampagras | Räucher-Baum | Hortensie |

# 李樂詩博士在她的《極地情緣》書內提到：

「北極熊因氣候變暖，覓食艱難。」

「我看見熊媽媽帶着子女漫無目的的遊蕩覓食，筋疲力盡，看來身子孱弱，滾圓可愛的大肚腩消失了。瘦身後的北極熊，『熊』風不再，彷彿落難皇帝變成了癟三，教人非常難過不忍，熊的影像至今難忘。」

「這批僅存二萬多的極地原居民，最終將會被誰迫害滅族，家破熊亡呢？」

(Lee, Rebecca,《極地情緣》, *Warrior Book*., 2014 ,Pg 44)

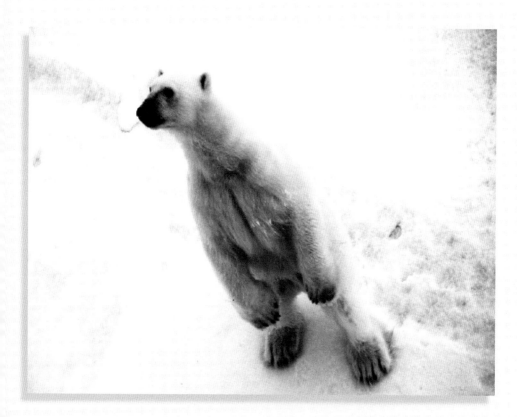

*北極熊
拍攝日期：2008 年 8 月　　地點：北冰洋，北緯：約 85 度
Polar bear 85 degrees north latitude 8/2008
Dr Rebecca Lee Lok Sze @Arctic Ocean
（* 資料及相片由李樂詩博士提供）

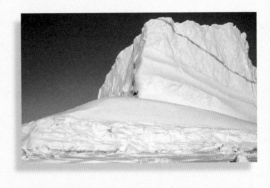

　　看到李博士在極地拍攝的北極熊，我在想，我可以用我的押花作品表達對於這瘦削北極熊的感受，而跟李博士商量之後我開始找材料，構思到創作，最後完成這幅作品。大家細心看看的話你會看到那只北極熊雖然身處在一個非常困難的環境，但仍然十分堅強。

　　李樂詩博士在極地拍攝北極熊的各種形態，而在眾多她拍攝的照片中，我決定用這張相（第15頁）作為我創作的參考，表達無論在任何逆境中，也可以堅強面對自己的未來。

Dr. Rebecca Lee Lok Sze is the first female Hong Konger to have visited all three extremes of the Earth - the North Pole, the South Pole, and Mount Everest. She is the founder of the China Polar Museum Foundation, the ex-president of the Hong Kong Association for the Advancement of Science and Technology, and member of the China Association for Expedition. The artwork above (page 15) is the collaboration between Dr. Lee and Dr. Serina Ha to raise individual awareness of environmental pollution and global warming, enabling the youth to take the environment into account in their daily lives. Dr. Serina Ha referred to the photo taken by Dr. Lee and produced this pressed flower art. The skinny polar bear is strong and confident - however, against all odds.

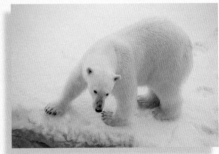

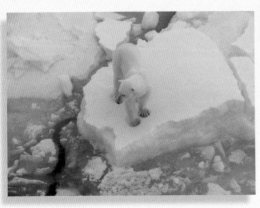

（16及17頁相片由李樂詩博士提供）

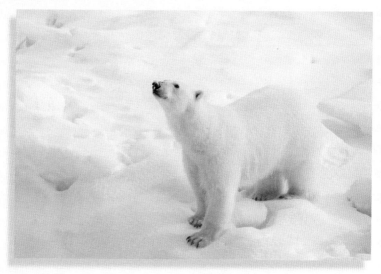

　　這作品另一個意義，是希望能加強所有朋友對環境的愛護，不只在極地，就在你身邊任何環境、植物和動物，希望你可以珍惜他們，給他們一個健康的成長環境。正正就是這一個意念，無論你現在身處任何困境，遇到甚麼人，甚麼事，只要你有一個信念，你一定可以面對難關、跨越自己。

------------------------------------------------------------

今次這本書的收益部分作為花材提供押花教學給需要資助的朋友，
亦會捐助極地博物館基金，協力推廣環境教育。
This book helps to raise a charity donation for student financial assistance of
pressed flower education and for the Polar Museum Foundation.

極地博物館基金
POLAR MUSEUM FOUNDATION

# 2

## 廣場裏的午餐——我愛巴黎
### Lunch in the Piazza - I love Paris

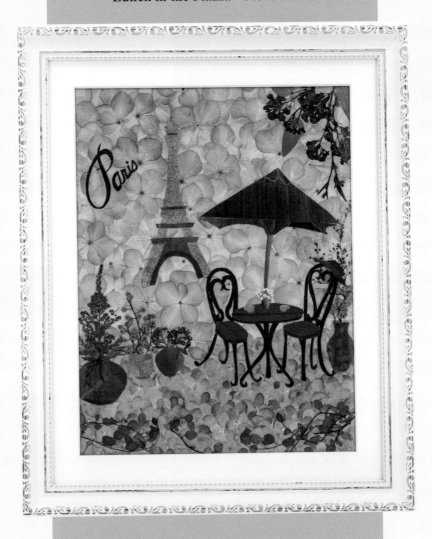

広場でのランチ - パリが大好き

광장에서 점심식사 – 파리를 사랑한다

Déjeuner sur la place - j'aime Paris

Mittagessen auf der Piazza - ich liebe Paris

*2020 美國費城年度花展押花冠軍
First Prize Award-Philadelphia Flower Show 2020, USA

# 花材 Materials

雨傘
Umbrella
傘
우산
Parapluie
Regenschirm

竹笋皮
Bamboo Shoot skin
竹の子の皮（タケノコノカワ）
죽순 껍질
Peau de pousse de bambou
Bambusspross Haut

枱及椅
Table & Chair
机と椅子
책상과 의자
Table et Chaise
Tisch und Stuhl

南天竹
Nandina Domestica
ナンテン
남천
Bambou Nanten
Der Himmelsbambus

銀白楊
Populus Alba
銀ポプラ
은백양
Peuplier argenté
Weiß-Pappel

埃菲爾鐵塔（巴黎鐵塔）
Eiffel Tower
エッフェル塔
에펠 탑
La Tour Eiffel
Der Eiffelturm

櫻花樹葉
Leaves of Cherry Blossom
桜の葉
벚꽃잎
Feuilles de cerisier
Kirschblätter

花瓶
Vase
花瓶
꽃병
Vase
Vase

櫻花樹葉
Leaves of Cherry Blossom
桜の葉
벚꽃잎
Feuilles de cerisier
Kirschblätter

繡球花
Hydrangea
アジサイ
수국
Hortensia
Hortensie

紙
Paper
台紙
대지
Papier
Papier

繡球花
Hydrangea
アジサイ
수국
Hortensia
Hortensie

百日草
Zinnia
ジニア
백일홍
Zinnia
Zinnie

咖啡杯
Coffee Cup
コーヒーカップ
커피 컵
Tasse à café
Kaffeetasse

飛燕草
Delphinium
デルフィニウム
델피늄
Pied-d'alouette
Rittersporn

巴黎
Paris
パリ
파리
Paris
Paris

三色菫
Pansy
パンジー
팬지
Viola wittrockiana
Garten-Stiefmütterchen

## 其他 Others

**落新婦**
Astilbe
アスチルベ
아스틸베
Pansy Astilbe
Prachtspieren

**小町藤**
Hardenbergia
ハーデンベルギア
하덴버지아
Harden Bengia
Hardenbergia

**銀荊**
Mimosa
ミモザ
미모사
Mimosa
Mimose

**香雪球**
Alyssum
アリッサム
알리섬
Alyssum
Steinkraut

**鐵線蔓**
Muehlenbeckia Axillaris
ワイヤープランツ
트리안
Muehlenbeckiar
Drahtpflanzen

**米香花**
Rice Flower
ライスフラワー
라이스 플라워
Fleur de riz
Reisblume

**董菜屬**
Viola
ビオラ
비올라
Viola
Veilchen

**繡球花**
Hydrangea
アジサイ
수국
Hortensia
Hortensie

# 從開始構思《廣場裏的午餐——我愛巴黎》

資料搜集

花材測試

雖則難度甚高

但在重複的練習中

學懂了　明白了

我到達美國費城花展的那一刻

也未知道結果

最終看見了作品

也看到了冠軍的名牌

經過六年的努力

終於成功了

為這作品喝彩

為香港爭取了冠軍

十分感恩

只要有信心

我們一定可以

大家加油

# 3

## 愛的世界
### Rhythm and Harmony

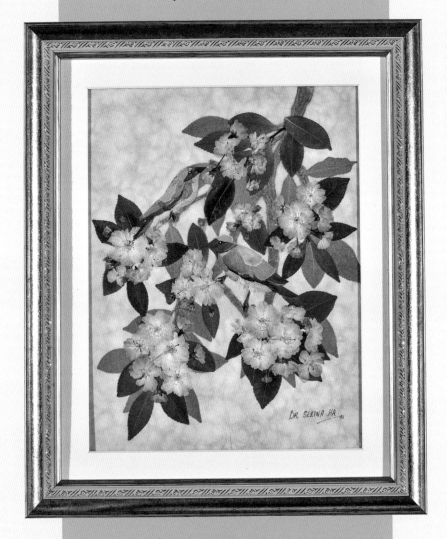

愛的世界
Rhythm and Harmony
愛の世界
사랑의 세계
Rythme et harmonie - monde de l'amour
Rhythmus und Harmonie - Weltbejahung

## 花材 Materials

**康乃馨**
Carnation
カーネーション
카네이션
œillet
Nelke

**飛燕草**
Delphinium
デルフィニウム
델피늄
Pied-d'alouette
Rittersporn

**百日草**
Zinnia
ジニア
백일홍
Zinnia
Zinnie

**八重櫻**
Double Cherry Blossom
ヤエザクラ
야에 자쿠라
Fleur de cerisier double
Doppelte Kirschblüte

**茶梅葉**
Leaves of Camellia Sasanqua
サザンカの葉
애기동백나무의 잎
Feuilles de Camellia
Sasanqua Kamelie Sasanqua laub

**蒲葦**
Pampas Grass
パンパスグラス
팜파스 그래스
Herbe de Pampa
Pampagras

慈善拍賣：2019 年 9 月 1 日捐贈予莫理士愛心行動基金
Donated to Morris Charity Initiative on September 1st 2019

# 李樂詩博士在她的《極地情緣》書內提到：

「從沒想過自己竟然登上珠峰雪域……深感大自然與人類關係和諧的重要……有幸參與，義不容辭。」(Lee, Rebecca,《極地情緣》, *Warrior Book*., 2014, Pg 61)

我把日本押花世界、押花藝術，在不同的教學領域及媒體中展出，2017 年捐贈拍賣予勵智協進會。而今次這作品在 2019 年 9 月在慈善活動上捐贈莫文蔚及母親的莫理士愛心行動基金，成為當晚最受觸目的作品之一，善款達五位數字。

作品是西部藍鳥 Western Bluebird，身長約 15 至 18 厘米。雄性的後背和頭部是明亮的藍色，橙色在兩側，背面有褐色斑點，還有灰色的腹部和隱蔽處。每年兩次，在全球範圍內，數億隻鳥類在繁殖和越冬地之間行進數千英里。不幸的是，與大自然的許多其他方面一樣，這些偉大的遷移受到各種威脅的壓力。以下是五個關鍵：

1. 自然環境中滅亡　2. 氣候變化　　　3. 人類 / 動物的侵襲
4. 農藥　　　　　5. 光污染

希望人們不要射擊鳥羣讓牠們可以安全健康地生活。

我實行做更多的藝術作品去把愛散播這個地方，希望你們也支持。

The intention of creating the art of Western Bluebird was to show more awareness to the caring of migration birds.

Five reasons we should care about migratory birds :

Twice a year, around the globe, hundreds of millions of birds travel thousands of miles between breeding and wintering grounds. Unfortunately, like many other aspects of nature, these great migrations are under pressure from a variety of threats. Below are five critical forces conservationists around the world are working to mitigate to preserve these great migrations for generations to come.

1. Habitat loss　　2. Climate change　　3. Human/ animal
4. Pesticides　　　5. Light Pollution

Please don't shoot the birds!

I hope us as global citizens can live peacefully with animals and not to bring harm to their lives. I hope through my creation of art, I can inspire each of you to cherish our living environment and the animals that are living with us together on this planet. I donated this art for the Morris Charity Initiative on the 1st of September 2019 to help raise money for Animal Asia.

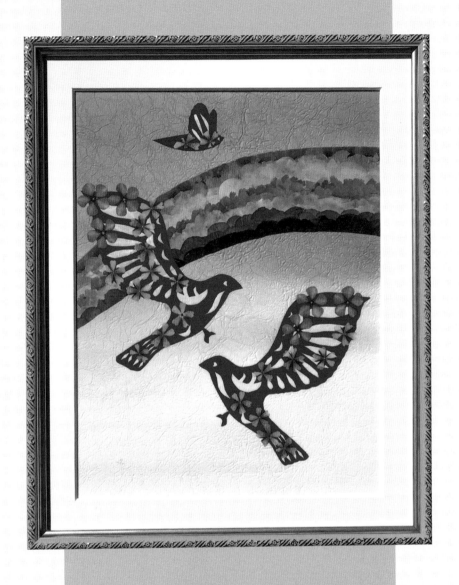

畫出彩虹　奔向和平！

Let's go - Peace world！

とどけ！平和へ

평화의 세계로 날아라！

On s'en va！au monde de la paix

Auf gehts! geht's zum Weltfrieden

為奧運運動員打氣、東京奧運公認節目——東京世界押花展

20-22/12/2019

東京花園露臺紀尾井町（展覽場）

## 花材 Materials

**菫菜屬**
Viola
ビオラ
비올라
Viola
Veilchen

**香豌豆**
Lathyrus odoratus
スイトピー
스위트피
Pois de senteur
Duftende Platterbse

**鐵線蕨**
Adiantum
アジアンタム
아디안텀
Adiantum
Adiantum

**天竺葵**
Geranium
ゼラニウム
제라늄
Géranium
Geranie

**飛燕草**
Delphinium
デルフィニウム
델피늄
Pied-d'alouette
Rittersporn

**馬鞭草**
Verbena
バーベナ
버베나
Verveine
Eisenkraut

**百日草**
Zinnia
ジニア
백일홍
Zinnia
Zinnie

這作品用中國剪紙技術加日本押花，以紅色的飛鴒奔向彩虹為題！

這個支持奧運運動員推廣押花的大型展覽會，從 1988 年漢城舉行的奧運會開始定時在世界各地舉行，可以參與，十分榮幸！

其中最大的目的是將香港的藝術文化（中國剪紙）可以在東京展出！

This is an encouragement to the Olympic athletes !

# 漣漪玫瑰
## Rippling Rose

漣漪玫瑰
Rippling Rose
波の花
졸졸 흐르는 장미
Rose ondulée
Welligkeit Rose

---------------------------------- **花材 Materials** ----------------------------------

**繡球花**
Hydrangea
アジサイ
수국
Hortensia
Hortensie

**天竺葵**
Geranium
ゼラニウム
제라늄
Géranium
Geranie

曾唱〈畫出彩虹〉的 Danny 陳百強
曾在 1988 年當年仍被稱為「漢城」（現稱為「首爾」）的奧運會前夜，
在韓國參加了當晚的「亞洲的光榮」歌謠節，與韓國歌手趙容弼、日
本歌手西城秀樹同台演出。

## 漣漪玫瑰

這作品的構思

是表達我對陳百強的懷念

我們是工作上的朋友亦是知己

他來電台做訪問

我們會先飲個茶

問候近況

無所不談

他常帶備一個公事包

內裏有一些他想同我分享的照片

我們平常也會去散步

去跳舞

去聽歌

最享受和他一起漫談的每一刻

我彷似進入了他的內心世界

我想像不到

多少年後的今天

我以我的押花作品讓大家

一邊賞花　一邊聆聽

Danny 的好歌

（麗乾花作品）

一生何求
What in life is worth chasing
人生で何を求めていますか
인생에서 원하는 것들
Que recherchez-vous dans votre vie
Was suchst du in deinem Leben

## 花材 Materials

| 杜鵑花 | 丁香花 | 小町藤 |
|---|---|---|
| Azaleas | Syringa | Hardenbergia |
| アザレア | バイカウツギ | ハーデンベルギア |
| 아잘레아 | 정향나무 | 하덴버지아 |
| Azalée | Lilas commun | Harden Bengia |
| Azalee | Flieder | Hardenbergia |

# 一生何求

Danny 情歌以外另一經典歌曲

迷茫中看不透，但手中所有已經是心中所想

努力尋夢後所想的已經在手

勉強追求有時候失去更多

失去的　其實是你的所有

這段日子你也許要面對一些人和事

可能會有一刻迷茫

人生中追逐的

是心中富有

Danny 追求的是心靈上的快樂

他珍惜身體邊每一個朋友及家人

他做自己喜歡的事

做真正的自己

## 紫色花

像湖上片片恬淡的味道
有一種愛是美
融和大地
宇宙都是一起　萬物像是一樣
呼吸、感覺都是一樣
愛是靜態及沒有空間
Danny 與我們的愛存在於萬物空間
到天地永恆

---

### 花材 Materials

| 海葵 | 千鳥草 | 石竹 |
|------|--------|------|
| Anemone | Larkspur | Dianthus |
| アネモネ | チドリソウ | 撫子（ナデシコ） |
| 아네모네 | 락스퍼 | 패랭이꽃 |
| Anémone | Pied-d'alouette | Dianthus |
| Anemone | Rittersporn | Dianthus |

# 5

## 維他命搖籃
### A Basket of Vitamin

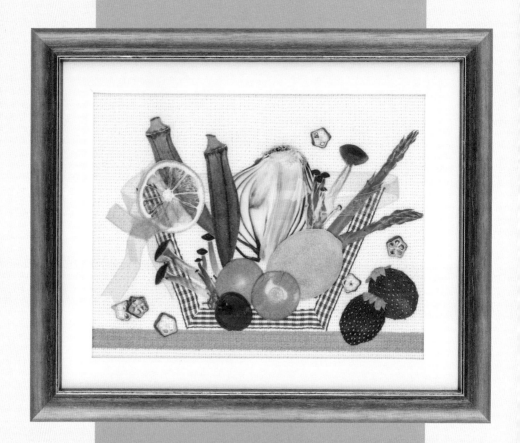

維他命搖籃
A Basket of Vitamin
ビタミンのバスケット
비타민 바스켓
Panier de vitamine
Vitamin mit Korb

## 花材 Materials

**檸檬**
Lemon
レモン
레몬
Citron
Zitrone

**士多啤梨**
Strawberry
苺（イチゴ）
딸기
Fraise
Erdbeere

**蘆筍**
Asparagus
アスパラガス
아스파리거스
Asperges
Spargel

**洋葱**
Onion
タマネギ
양파
Oignon
Zwiebel

**秋葵**
Okra
オクラ
오크라
Gombo
Gemüse-Eibisch

**野胡蘿蔔**
Daucus carota
ニンジン
당근초
Carotte
Karotte

**小番茄**
Mini Tomato
プチトマト
미니 토마토
Tomate cerise
Mini Tomate

# 怎樣去培養小朋友對藝術的興趣？

三歲學芭蕾舞

四歲學小提琴

五歲入校隊

一人一運動

一人一樂器

這是大人定下來的升學條件

到底小孩朋友真正喜歡甚麼？

這課我的作品是生果籃、小狗、公主裙

希望可以啟發小朋友的創意

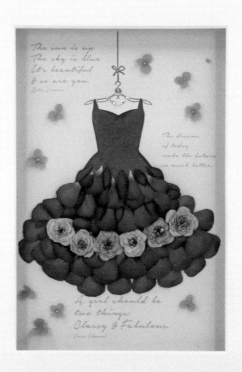

美若玫瑰的妳
You are Lovely as Rose - So This is Love
君は薔薇より美しい
장미처럼 예쁜 너
Ous êtes aussi belle que la rose - C'est ça l'amour
Du bist lieblich wie Rose - Das ist Liebe

------------------------------- **花材 Materials** -------------------------------

| 陸蓮花 | 小玫瑰 | 網紋草 |
|---|---|---|
| Persian buttercup | Mini Rose | Fittonia |
| ラナンキュラス | ミニバラ | フィットニア |
| 러넌큘러스 | 미니 장미 | 피토니아 |
| Renoncule des fleuristes | Mini rose | Fittonia |
| Asiatischer Hahnenfuß | Mini rose | Fittonien |

（麗乾花作品）

單車
Bicycle
自転車
자전거
Vélo
Fahrrad

## 花材 Materials

| 繡球花 | 小玫瑰 | 小町藤 |
|--------|--------|--------|
| Hydrangea | Mini Rose | Hardenbergia |
| アジサイ | ミニバラ | ハーデンベルギア |
| 수국 | 미니 장미 | 하덴버지아 |
| Hortensia | Mini rose | Harden Bengia |
| Hortensie | Mini rose | Hardenbergia |

你是我的陽光
You are My Sunshine

# 大自然之迴響
## Voice of Nature

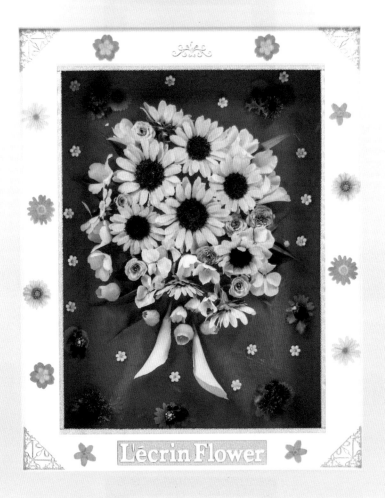

（麗乾花作品）

大自然之迴響 *
Voice of Nature
大自然の声
자연의 소리
Voix de la nature
Der schöne Stimme der Natur

* 日本麗乾花大賽佳作榮譽獎
Semi Finalist Honor
Oshibana Art & L'écrin Flower Art Contest, Japan
L'écrin Flower Association (2018)

## 花材 Materials

**向日葵**
Sun Flower
ヒマワリ
해바라기
Fleur de soleil
Sonnenblume

**海芋**
Calla Lily
カラー
칼라 릴리
Calla lis
Gewöhnliche Calla

**六出花**
Alstroemeria
アルストロメリア
알스트로메리아
Alstroemère (Lys des Incas)
Peruanische Lilie

**菫菜屬**
Viola
ビオラ
비올라
Viola
Veilchen

**宮燈百合**
Sandersonia
サンダーソニア
산데르소니아
Sandersonia
Sandersonia

**小玫瑰**
Mini Rose
ミニバラ
미니 장미
Mini rose
Mini rose

**丁香花**
Syringa
バイカウツギ
정향나무
Lilas commun
Flieder

感受身邊的事物

感受大自然

Feel the nature with Pressed Flower

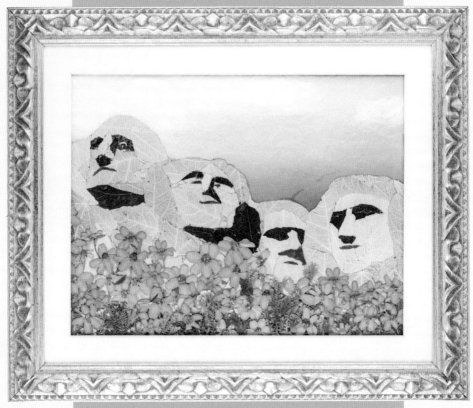

遙望總統山
Explore Mount Rushmore
ラシュモア山 を見ます
러시모어 산을 바라본다
Explorez Mount Rushmore
Erkunden Mount-Rushmore

"Explore America- Mount Rushmore National Memorial,
South Dakota

2016 美國費城年度花展
Philadelphia Flower Show 2016, USA

------------------ 花材 Materials ------------------

| 百日草 | 銀白楊 |
|---|---|
| Zinnia | Populus Alba |
| ジニア | 銀ポプラ |
| 백일홍 | 은백양 |
| Zinnia | Peuplier argenté |
| Zinnie | Weiß-Pappel |

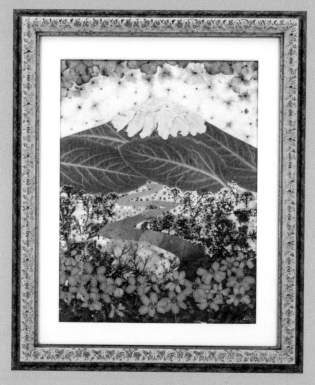

在彎曲的道路 - 向富士山中
A Long & Winding Road to Fuji Mountain
富士山へ登ろう！
후지산으로 가는 길고 구불구불한 길
Une route longue et sinueuse vers la montagne Fuji
Eine lang und Kurvenreich Straße nach Berg Fuji

2019 美國費城年度花展
Philadelphia Flower Show 2019, USA

## 花材 Materials

| 繡球花 | 銀葉菊 | 綿毛水蘇 |
|---|---|---|
| Hydrangea | acobaea maritima | Stachys byzantina |
| アジサイ | シロタエギク | ラムズイヤー |
| 수국 | 백묘국 | 램즈이어 |
| Hortensia | Séneçon d'argent | Épiaire de Byzance |
| Hortensie | Aschenpflanze | Woll-Ziest |

| 香雪球 | 櫻花樹葉 | 馬鞭草 | 百日草 |
|---|---|---|---|
| Alyssum | Leaves of Cherry Blossom | Verbena | Zinnia |
| アリッサム | 桜の葉 | バーベナ | ジニア |
| 알리섬 | 벚꽃잎 | 버베나 | 백일홍 |
| Alyssum | Feuilles de cerisier | Verveine | Zinnia |
| Steinkraut | Kirschblätter | Eisenkraut | Zinnie |

花的世界無限可能

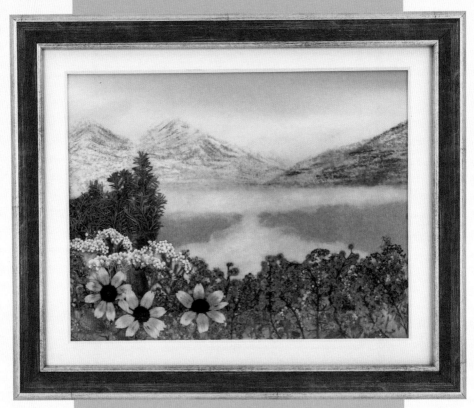

回憶中的路易斯湖（掃描篇）
Memory of Lake Louise
思い出のルイーズ湖
추억의 루이즈 호
Mémoire de Lake Louise
Erinnerung an Louise see

## 花材 Materials

| | | |
|---|---|---|
| **柏葉** | **米香花** | **小岩桐** |
| Cypress leaf | Rice Flower | Gloxinia Sylvatica |
| 檜葉（ヒバ） | ライスフラワー | シーマニア |
| 사이프러스 잎 | 라이스 플라워 | 글록시니아 |
| feuille de cyprès | Fleur de riz | Gloxinia |
| Zypressenblatt | Reisblume | Gloxinia |
| | | |
| **百日草** | **香雪球** | **銀荊** |
| Zinnia | Alyssum | Mimosa |
| ジニア | アリッサム | ミモザ |
| 백일홍 | 알리섬 | 미모사 |
| Zinnia | Alyssum | Mimosa |
| Zinnie | Steinkraut | Mimose |

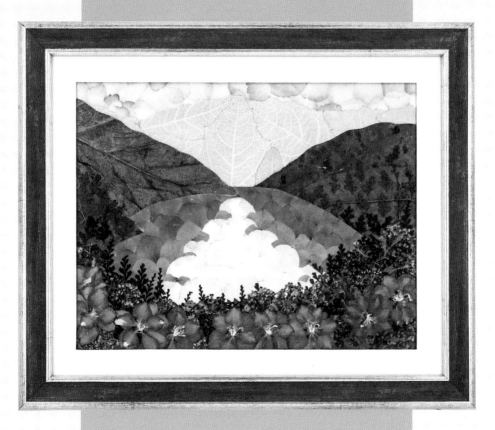

回憶中的路易斯湖（全押花篇）
Memory of Lake Louise
思い出のルイーズ湖
추억의 루이즈 호
Mémoire de Lake Louise
Erinnerung an Louise see

## 花材 Materials

| 繡球花 | 櫻花樹葉 |
|---|---|
| Hydrangea | Leaves of Cherry Blossom |
| アジサイ | 桜の葉 |
| 수국 | 벚꽃잎 |
| Hortensia | Feuilles de cerisier |
| Hortensie | Kirschblätter |

| 飛燕草 | 香雪球 | 銀白楊 |
|---|---|---|
| Delphinium | Alyssum | Populus Alba |
| デルフィニウム | アリッサム | 銀ポプラ |
| 델피늄 | 알리섬 | 은백양 |
| Pied-d'alouette | Alyssum | Peuplier argenté |
| Rittersporn | Steinkraut | Weiß-Pappel |

花的世界無限可能

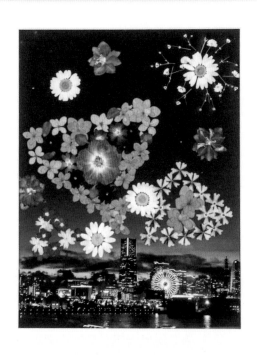

煙火・夜
Night View of Fireworks
花火の夜景
불꽃의 야경
Vue nocturne des feux d'artifice
Nachtansicht des Feuerwerk

## 花材 Materials

**繡球花**
Hydrangea
アジサイ
수국
Hortensia
Hortensie

**白晶菊**
Leucanthemum paludosum
ノースポール
미니어쳐 마거리트
Leucanthemum paludosum
Magerwiesen-Margerite

**霞草**
Gyposophila Elegans
かすみそう
안개꽃
Gyposophila Elegans
Gyposophila Elegans

**馬鞭草**
Verbena
バーベナ
버베나
Verveine
Eisenkraut

**千鳥草**
Larkspur
チドリソウ
락스퍼
Pied-d'alouette
Rittersporn

# 7

## 一起
### Together
世界更美只因有你

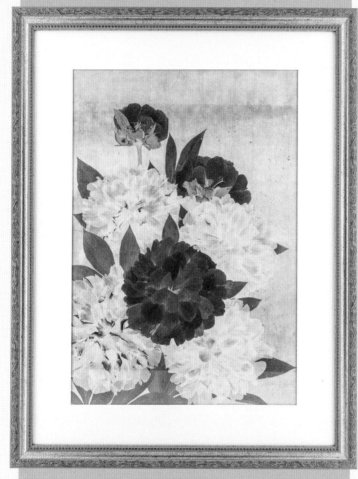

一起
Together
一緒に
같이
Ensemble
Alle zusammen

-------------------- **花材 Materials** --------------------

芍藥
Paeonia lactiflora (Sakuyaku)
芍薬（シャクヤク）
작약
Paeonia lactiflora
Edel-Pfingstrosen

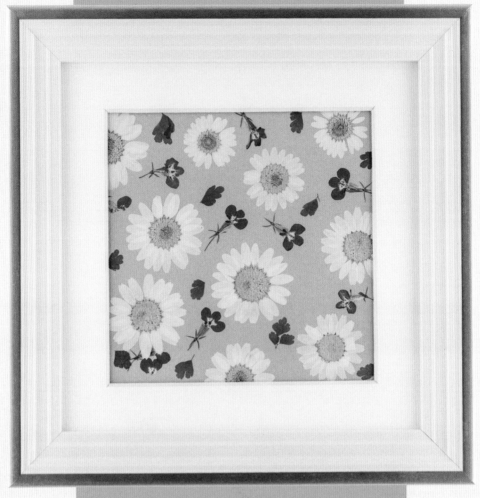

歡顏

Charming Smiles

可愛い顔

귀여운 미소

Sourire Charmant

Bezauberndes Lächeln

## 花材 Materials

| 白晶菊 | 半邊蓮 | 鐵線蕨 |
|---|---|---|
| Leucanthemum paludosum | Lobelia | Adiantum |
| ノースポール | ロベリア | アジアンタム |
| 미니어쳐 마거리트 | 로벨리아 | 아디안팀 |
| Leucanthemum paludosum | Lobélie | Adiantum |
| Magerwiesen-Margerite | Blaue Lobelie | Adiantum |

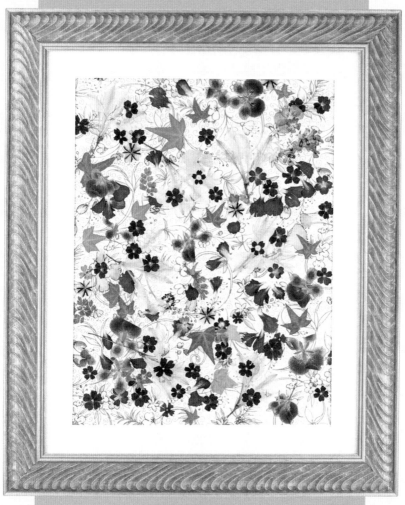

全有愛
Love is in the Air
愛は空気中です
사랑은이 공중에 있다
L'amour est dans l'air
Liebe liegt in der Luft

## 花材 Materials

| 馬鞭草 | 天竺葵 | 常春藤 | 康乃馨 |
|---|---|---|---|
| Verbena | Geranium | Hedera (Ivy) | Carnation |
| バーベナ | ゼラニウム | アイビー | カーネーション |
| 버베나 | 제라늄 | 아이비 | 카네이션 |
| Verveine | Géranium | Lierre | Ceillet |
| Eisenkraut | Geranie | Efeu | Nelke |

# 8

## 常在我心間

### Always on my Mind

有些人總是令你難忘
這部分的作品作為懷念你身邊的人
我們一直銘記在心的
每一個人

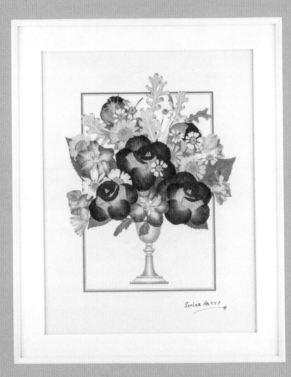

Serian Hart

常在我心間
Always on my Mind
いつも私の心に
항상 내 마음 속에 있다
Toujours dans mon esprit
Du bist immer noch in meinem Kopf

---

## 花材 Materials

| 玫瑰 | 千鳥草 | 夏白菊 |
|---|---|---|
| Rose | Larkspur | Tanacetum parthenium |
| バラ | チドリソウ | マトリカリア |
| 장미 | 락스퍼 | 피버퓨 |
| Rose | Pied-d'alouette | Tanacetum parthenium |
| Rose | Rittersporn | Zierkamille |

# 2020 年為鄧麗君小姐的逝世 25 年

我們對她的懷念

彷似這作品

任何時候

長伴我心

千言萬語

多謝鄧姐的歌聲陪伴我

漫步人生路

我只在乎你

花
的
世
界
無
限
可
能

（麗乾花作品）

無盡的愛
Everlasting
永遠
영원한 사랑
Éternel
Ewig

## 花材 Materials

| 白晶菊 | 菫菜屬 | 小町藤 |
|---|---|---|
| Leucanthemum paludosum | Viola | Hardenbergia |
| ノースポール | ビオラ | ハーデンベルギア |
| 미니어쳐 마거리트 | 비올라 | 하덴버지아 |
| Leucanthemum paludosum | Viola | Harden Bengia |
| Magerwiesen-Margerite | Veilchen | Hardenbergia |

對梅艷芳 無盡的愛

相識是緣份

妳是芳華絕代

交出我的心

永遠 Stand by me

愛慕　　（麗乾花作品）

Feel So Sweet

愛を感じます

사랑을 느낀다

Sentez-vous si doux

sich süß fühlen

## 花材 Materials

**木茼蒿**
Argyranthemum frutescens
マーガレット
마가렛목재
Argyranthemum frutescens
Argyranthemum frutescens

**白晶菊**
Leucanthemum paludosum
ノースポール
미니어쳐 마거리트
Leucanthemum paludosum Magerwiesen-Margerite

**瓜葉菊**
Cineraria
サイネリア
시네라리아
Cinéraria
Cineraria

**小町藤**
Hardenbergia
ハーデンベルギア
하덴버지아
Harden Bengia
Hardenbergia

**香雪球**
Alyssum
アリッサム
알리섬
Alyssum
Steinkraut

張國榮 型格的台風

大熱的舞姿

永受人愛慕

我們讓風繼續吹

感覺甜蜜地

永遠為你鍾情

# 9

## 約定
### Promise me

給甜蜜的一對
愛的組合系列

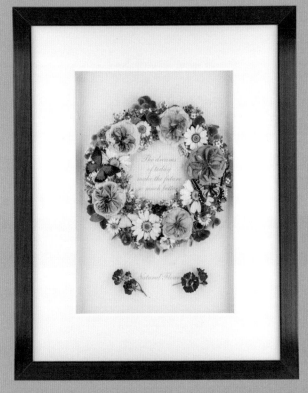

（麗乾花作品）

約定
Promise me
約束 して
약속한다
Promets-moi
Zusage

## 花材 Materials

| 小玫瑰 | 天竺葵 | 白晶菊 | 香雪球 |
|---|---|---|---|
| Mini Rose | Geranium | Leucanthemum paludosum | Alyssum |
| ミニバラバラ | ゼラニウム | ノースポール | アリッサム |
| 미니 장미 | 제라늄 | 미니어쳐 마거리트 | 알리섬 |
| Mini rose | Géranium | Leucanthemum paludosum | Alyssum |
| Mini rose | Geranie | Magerwiesen-Margerite | Steinkraut |

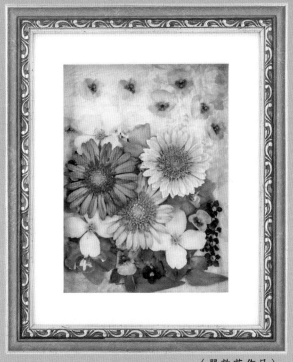

（麗乾花作品）

永恆
Eternity
永遠
영원
Éternité
ewig

## 花材 Materials

| 非洲菊 | 梅花空木 |
| --- | --- |
| Gerbera | Philadelphus Satsumi |
| ガーベラ | バイカウツギ |
| 거베라 | 고광나무 |
| Gerbera | Philadelphus Satsumi |
| Gerbera | Philadelphus Satsumi |

| 飛燕草 | 宿根草 | 紫芳草 |
| --- | --- | --- |
| Delphinium | Perennial Plant | Exacum Affine |
| デルフィニウム | ディアシア ダーラ | エキザカム |
| 델피늄 | 숙근초 | 엑사쿰 |
| Pied-d'alouette | Plante vivace | Exacum Affine |
| Rittersporn | Mehrjährig | Blaue Lieschen |

慶祝日本令和新年的押花作品──夢想花系列
這個重生的感覺：重新包裝、重新出發、配合新的契機，人生再開始！
Reiwa - a new Era in Japan

花
的
世
界
無
限
可
能

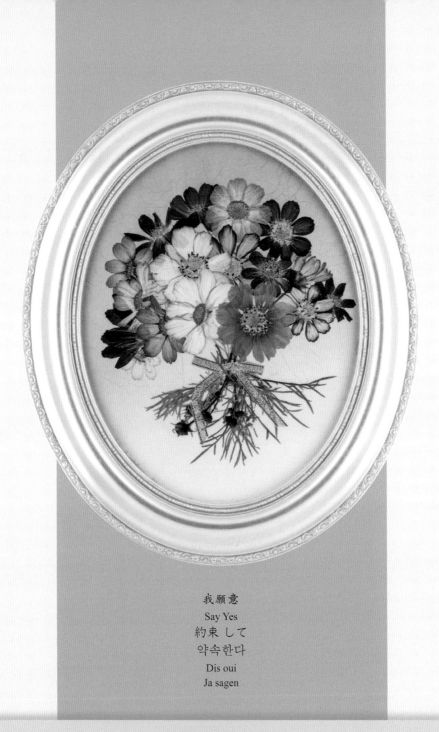

我願意
Say Yes
約束 して
약속한다
Dis oui
Ja sagen

## 花材 Materials

大波斯菊
Cosmos
秋桜（コスモス）
코스모스
Cosmos
Cosmea

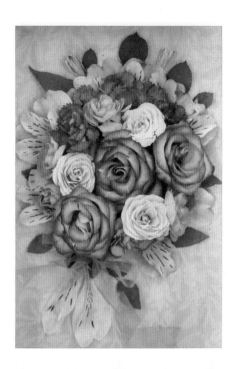

（麗乾花作品）

只有你
Only You
オンリー・ユー
너 밖에 없다
Seulement toi
Nur du

## 花材 Materials

**噴霧玫瑰**
Spray Rose
スプレー バラ
스프레이 로즈
Rose Vaporisateur
Verzweigte Rose

**六出花**
Alstroemeria
アルストロメリア
알스트로메리아
Alstroemeria
Peruanische Lilie

花
的
世
界
無
限
可
能

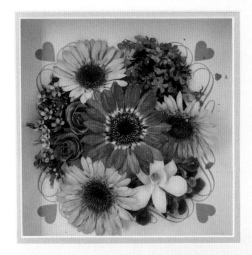

（麗乾花作品）

戀之花
Flower of Romance
恋の花
로맨스의 플라워
Fleur de romance
Blume der Romantik

## 花材 Materials

| 非洲菊 | 蠟花 | 噴霧玫瑰 | 石斛蘭 |
|---|---|---|---|
| Gerbera | Wax flower | Spray Rose | Denfare |
| ガーベラ | ワックスフラワー | スプレー バラ | デンファレ |
| 거베라 | 왁스플라워 | 스프레이 로즈 | 덴파레 |
| Gerbera | Fleur de cire | Rose Vaporisateur | Denfare |
| Gerbera | Wachsblume | Verzweigte Rose | Denfare |

| 馬鞭草 | 小町藤 | 天竺葵 | 半邊蓮 |
|---|---|---|---|
| Verbena | Hardenbergia | Geranium | Lobelia |
| バーベナ | ハーデンベルギア | ゼラニウム | ロベリア |
| 버베나 | 하덴버지아 | 제라늄 | 로벨리아 |
| Verveine | Harden Bengia | Géranium | Lobélie |
| Eisenkraut | Hardenbergia | Geranie | Blaue Lobelie |

## 國際獎
### International Award

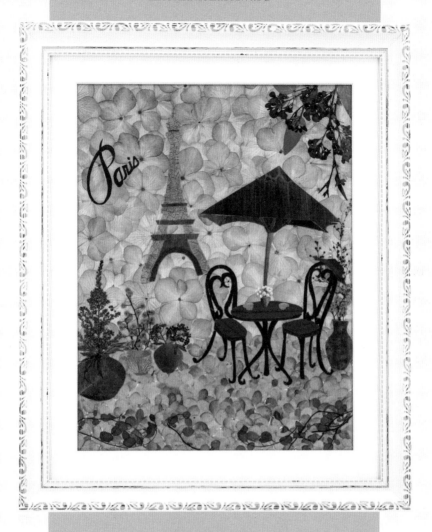

廣場裏的午餐 —— 我愛巴黎 *
Lunch in the Piazza - I love Paris
広場でのランチ - パリが大好き
광장에서 점심식사 – 파리를 사랑한다
Déjeuner sur la place - j'aime Paris
Mittagessen auf der Piazza - ich liebe Paris

\* 美國費城第 191 屆花展押花組冠軍
First Prize Award-Philadelphia Flower Show 2020, USA

# 花材 Materials

雨傘
Umbrella
傘
우산
Parapluie
Regenschirm

竹筍皮
Bamboo Shoot skin
竹の子の皮（タケノコノカワ）
죽순 껍질
Peau de pousse de bambou
Bambusspross Haut

枱及椅
Table & Chair
机と椅子
책상과 의자
Table et Chaise
Tisch und Stuhl

南天竹
Nandina Domestica
ナンテン
남천
Bambou Nanten
Der Himmelsbambus

銀白楊
Populus Alba
銀ポプラ
은백양
Peuplier argenté
Weiß-Pappel

埃菲爾鐵塔（巴黎鐵塔）
Eiffel Tower
エッフェル塔
에펠 탑
La Tour Eiffel
Der Eiffelturm

櫻花樹葉
Leaves of Cherry Blossom
桜の葉
벚꽃잎
Feuilles de cerisier
Kirschblätter

花瓶
Vase
花瓶
꽃병
Vase
Vase

櫻花樹葉
Leaves of Cherry Blossom
桜の葉
벚꽃잎
Feuilles de cerisier
Kirschblätter

繡球花
Hydrangea
アジサイ
수국
Hortensia
Hortensie

紙
Paper
台紙
대지
Papier
Papier

繡球花
Hydrangea
アジサイ
수국
Hortensia
Hortensie

百日草
Zinnia
ジニア
백일홍
Zinnia
Zinnie

咖啡杯
Coffee Cup
コーヒーカップ
커피 컵
Tasse à café
Kaffeetasse

飛燕草
Delphinium
デルフィニウム
델피늄
Pied-d'alouette
Rittersporn

巴黎
Paris
パリ
파리
Paris
Paris

三色菫
Pansy
パンジー
팬지
Viola wittrockiana
Garten-Stiefmütterchen

# 其他 Others

落新婦
Astilbe
アスチルベ
아스틸베
Pansy Astilbe
Prachtspieren

小町藤
Hardenbergia
ハーデンベルギア
하덴버지아
Harden Bengia
Hardenbergia

銀荊
Mimosa
ミモザ
미모사
Mimosa
Mimose

香雪球
Alyssum
アリッサム
알리섬
Alyssum
Steinkraut

鐵線蔓
Muehlenbeckia Axillaris
ワイヤープランツ
트리안
Muehlenbeckiar
Drahtpflanzen

米香花
Rice Flower
ライスフラワー
라이스 플라워
Fleur de riz
Reisblume

菫菜屬
Viola
ビオラ
비올라
Viola
Veilchen

繡球花
Hydrangea
アジサイ
수국
Hortensia
Hortensie

（麗乾花作品）

大自然之迴響 *
Voice of Nature
大自然の声
자연의 소리
Voix de la nature
Der schöne Stimme der Natur

## 花材 Materials

| | | |
|---|---|---|
| **向日葵** | **海芋** | **水仙百合** |
| Sun Flower | Calla Lily | Alstroemeria |
| ヒマワリ | カラー | アルストロメリア |
| 해바라기 | 칼라 릴리 | 알스트로메리아 |
| Fleur de soleil | Calla lis | Alstroemère (Lys des Incas) |
| Sonnenblume | Gewöhnliche Calla | Peruanische Lilie |

| | | | |
|---|---|---|---|
| **董菜屬** | **宮燈百合** | **小玫瑰** | **丁香花** |
| Viola | Sandersonia | Mini Rose | Syringa |
| ビオラ | サンダーソニア | ミニバラバラ | バイカウツギ |
| 비올라 | 산데르소니아 | 미니 장미 | 정향나무 |
| Viola | Sandersonia | Mini rose | Lilas commun |
| Veilchen | Sandersonia | Mini rose | Flieder |

花的世界無限可能

日本麗乾花大賽佳作榮譽獎 (2018)

Best Art Award
12th Japan L'écrin Flower Contest Japan L'écrin Flower Association

佳作
12回レカンフラワー　コンテスト
レカンフラワー協会

2018年參加了日本全國麗乾花大賽

得到佳作獎

作品參加展覽及活動年刊上載

2019年4月在日本展出

2020年香港的個人展出

愛護環保大自然

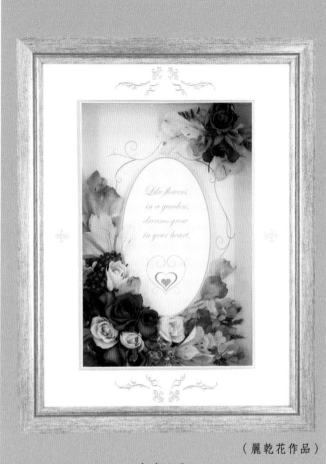

<div align="right">（麗乾花作品）</div>

永遠的夏 *
Forever Summer
永遠の夏
영원한 여름
Pour toujours l'été
Für immer Sommer

## 花材 Materials

**噴霧玫瑰**
Spray Rose
スプレー バラ
스프레이 로즈
Rose Vaporisateur
Verzweigte Rose

**六出花**
Alstroemeria
アルストロメリア
알스트로메리아
Alstroemeria
Peruanische Lilie

**繡球**
Hydrangea
アジサイ
수국
Hortensia
Hortensie

**三角梅**
Bougainvillea
ブーゲンビリア
부겐빌레아
Bougainvillier
Bougainvillea

**馬鞭草**
Verbena
バーベナ
버베나
Verveine
Eisenkraut

花
的
世
界
無
限
可
能

日本麗乾花大賽佳作榮譽獎（2017）

Best Art Award
11th Japan L'écrin Flower Contest Japan L'écrin Flower Association

佳作
１１回レカンフラワー　コンテスト
レカンフラワー協会

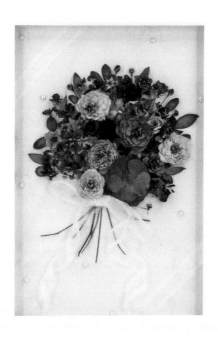

（麗乾花作品）

歡喜 *

Forever Love You

愛してる

사랑한다

Je t'aime pour toujours

Ich liebe dich für immer und ewig

*美國費城第 188 屆花展押花組最佳報導榮譽獎

Honorable Mention Award-Philadelphia Flower Show 2017 , USA

-------------------- 花材 Materials --------------------

| 噴霧玫瑰 | 小町藤 |
|---|---|
| Spray Rose | Hardenbergia |
| スプレー バラ | ハーデンベルギア |
| 스프레이 로즈 | 하덴버지아 |
| Rose Vaporisateur | Harden Bengia |
| Verzweigte Rose | Hardenbergia |

（麗乾花作品）

歡欣難年 *
The Wonderful Year of Chicken
喜び鳥な年
아름다운 닭의 해
La merveilleuse année du coq
Wunderschön Jahr Hühnchen

\* 美國費城第 188 屆花展押花組最佳報導榮譽獎
Honorable Mention Award-Philadelphia Flower Show 2017 , USA

---

## 花材 Materials

| | | | |
|---|---|---|---|
| **繡球花** | **千鳥草** | **白晶菊** | **半邊蓮** |
| Hydrangea | Larkspur | Leucanthemum paludosum | Lobelia |
| アジサイ | チドリソウ | ノースポール | ロベリア |
| 수국 | 락스퍼 | 미니어처 마거리트 | 로벨리아 |
| Hortensia | Pied-d'alouette | Leucanthemum Paludosum | Lobélie |
| Hortensie | Rittersporn | Magerwiesen-Margerite | Blaue Lobelie |

| | | |
|---|---|---|
| **小玫瑰** | **天竺葵** | **香雪球** |
| Mini Rose | Geranium | Alyssum |
| ミニバラバラ | ゼラニウム | アリッサム |
| 미니 장미 | 제라늄 | 알리섬 |
| Mini rose | Géranium | Alyssum |
| Mini rose | Geranie | Steinkraut |

（麗乾花作品）

羊年吉慶 *
A Wonderful Year of Goat
未年（ひつじどし）- 素晴らしい！
아름다운 양의 해
La merveilleuse année du chèvre
Wunderschön Jahr Ziege

-------------------- **花材 Materials** --------------------

銀葉菊
Silver Ragwort
シルバーレース
백묘국
Métallisé jacobée
Aschenpflanze

飛燕草
Delphinium
デルフィニウム
델피늄
Pied-d'alouette
Rittersporn

飾帶花
Trachymene coerulea
レースフラワー
레이스 플라워
Trachymène bleu
Blaudolde

花
的
世
界
無
限
可
能

韓國第9屆高陽市年度花展 押花大賽榮譽獎
（羊年吉慶）　（2015）
（高陽市長頒發）
（唯一香港入圍）

Diploma of Honor
The 9th World Pressed Flower Craft Exhibition Goyang Korea 2015
Presented by Mayor of Goyang City Choi, Seong

# 日本押花──夢想花系列
## Japanese Pressed Flower Art- Dream Flower Series

日本押花 之 夢想花

把押花設計放進一個放入少量花用油的袋中

放在窗前有陽光可以投射

更加立體及久存

# *12*

# 押花預防認知障礙症
## Pressed Flower - How to Prevent Dementia

日本押花如何預防認知障礙症

這是一個簡易的押花課程

適合任何年齡朋友

提供對這個病症的基本資料及常識

對家人照顧或對自己的預防

以及藝術自我啟發

希望更多朋友受惠

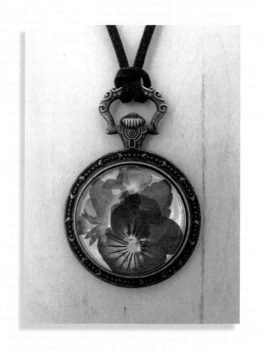

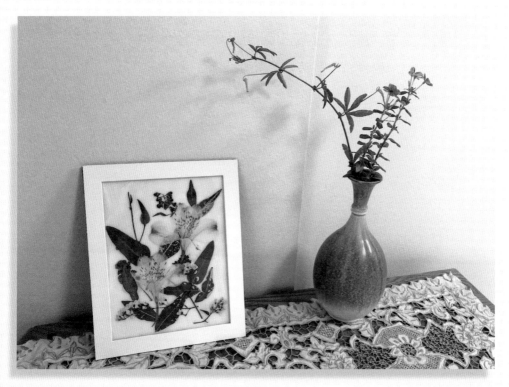

# *13*

## 花的世界無限可能——工作坊分享
### Chances to Possibilities - Pressed Flower Workshop

## 在押花的世界

我看見笑臉，暖意，關懷和驚喜

我押花工作坊學生中有

幼稚園的小朋友

年輕人、學生、復康朋友、長者朋友

他們總帶着歡笑離開課堂，亦結識很多新朋友

我協助他們在不同的地方舉辦展覽會

看到他們帶同家人來看自己的作品時

那些雀躍表情

深感安慰

押花帶給你新希望

創造更好的人生

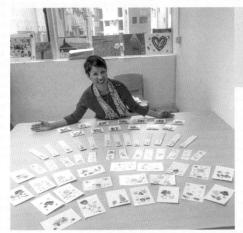

新生精神康復會安泰軒（油尖旺）工作坊
Pressed Flower Workshop of New Life Psychiatric Rehabilitation Association (The Wellness Centre)(Yau Tsim Mong)

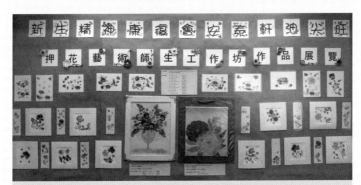

新生精神康復會安泰軒（油尖旺）會員作品在港鐵站展覽
Exhibition at MTR

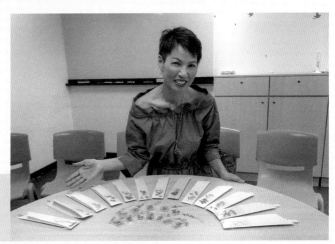

會員作品——押花筷子套
Students' artwork- Pressed Flower Chopsticks holder

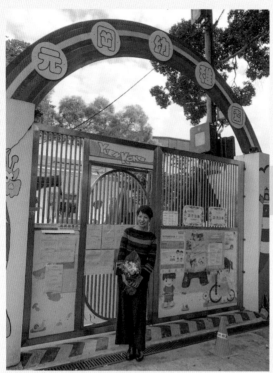

元崗幼稚園工作坊
Yuen Kong Kindergarten Workshop

元崗幼稚園工作坊
Yuen Kong Kindergarten Workshop

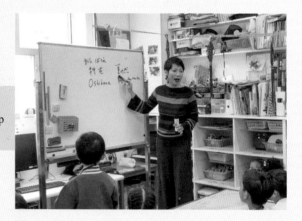

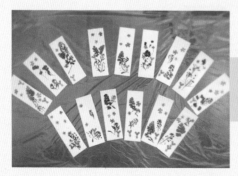

元崗幼稚園學員作品
押花書籤
Students' artwork- Pressed flower Bookmark

勵智協進會工作坊
Pressed flower workshop of
the Intellectually Disabled
Education and Advocacy
League Limited Workshop

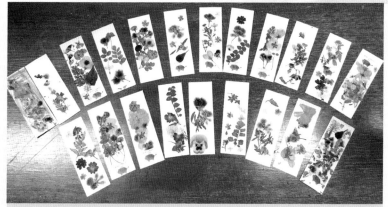

學員作品——押花書簽
Students' artwork-Pressed Flower Bookmark

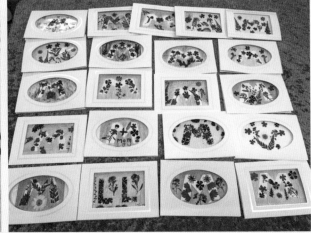

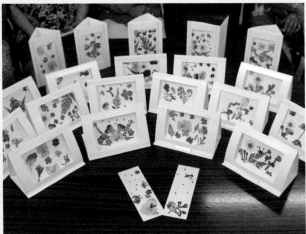

明愛沙田長者中心—明愛第三齡服務支援網路學員作品
押花母親節賀咭 / 押花筷子套
Botanic workshop for Caritas Support Network for Third Age Services
Students' artwork - Pressed Flower Mothers day Card/ Chopsticks Holder

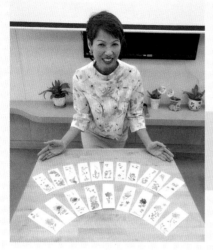

香港聖公會福利協會彩齡學院
Japanese Botanic Art Workshop of Hong Kong Sheng
Kung Hui Welfare Council Limited - Vitalita Academy
For Life Long Learning

香港聖公會福利協會彩齡學院師生
作品在港鐵站展覽
Exhibition of Members and Dr Ha
at MTR

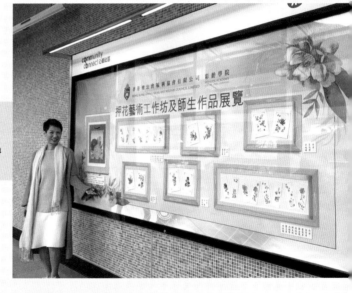

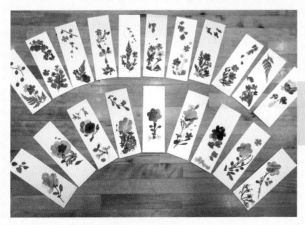

學員作品——押花書籤
Students' artwork-Pressed
Flower Bookmark

花
的
世
界
無
限
可
能

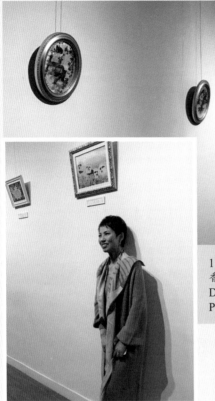

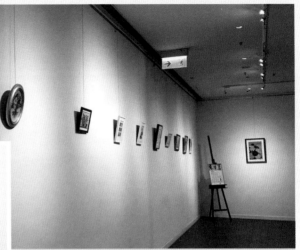

17-27/3/2017
香港大學個人作品展
Dr. Serina Ha's "Chances to Possibilities" HKU
Pressed Flower Exhibition

夏妙然博士、許廷鏗
Dr. Serina Ha, Alfred Hui

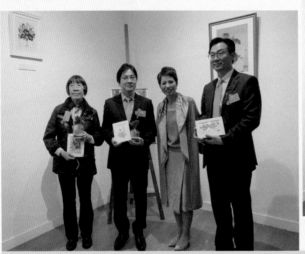

（由左至右）李樂詩博士、日本國駐香港總領事館廣報文化部前領事後藤龍太先生、
夏妙然博士、大韓民國文化體育觀光部總幹事俞炳采先生
(From Left to Right) Dr. Rebecca Lee Lok Sze, Mr. Ryuta GOTO (Former Consul of
Public Relations & Cultural Affairs Division, Consulate-General of Japan in Hong
Kong), Dr Serina Ha, Mr Yu Byung-Chae (Director General of Korean Culture and
Information Service, Ministry of Culture, sports and Tourism, Korea)

香港大學校友會押花工作坊
HKU Alumni Association Pressed
Flower Workshop

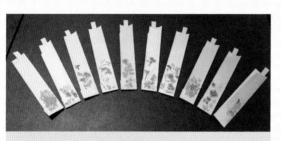

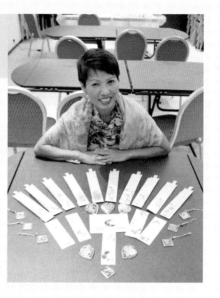

會員作品——押花筷子套
Students' artwork - Pressed Flower Chopsticks
holder

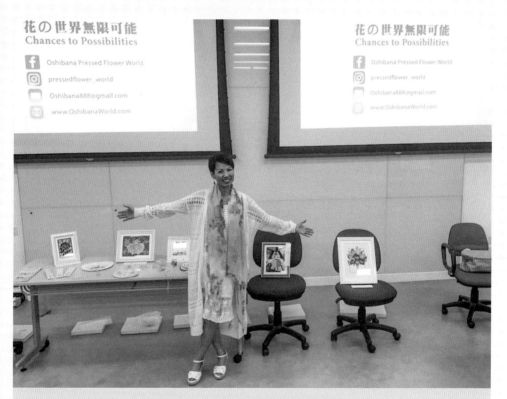

香港大學現代語言及文化學院——學術講座 / 日本押花工作坊
Academic Talk/ Pressed Flower Workshop of School of Modern Languages and
Cultures of the University of Hong Kong Workshop

花的世界無限可能

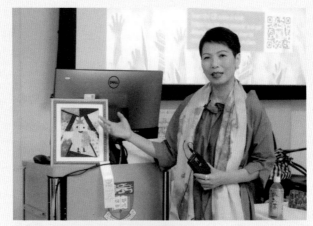

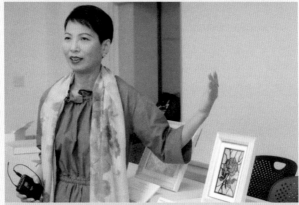

香港大學日本學會──日本押花工作坊
Japan Society, Arts Association, HK University
Students' Union-Japanese Pressed Flower Workshop

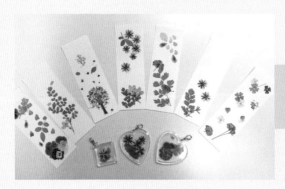

學員作品──押花書籤／押花鎖匙扣
Students' artwork-Pressed Flower
Bookmark/Pressed Flower Keyholder

香港浸會大學 Hong Kong Baptist University
學員作品——押花鎖匙扣
Students' artwork-Pressed Flower Keyholder

香港城市大學 Hong Kong City University
學術講座及分享會
Academic Talk and Pressed Flower Art Sharing Session

花的世界無限可能

香港恒生大學
Hang Seng University
of Hong Kong
10/4-30/4/2018
日本押花藝術
恒生大學個人作品展 /
工作坊
Dr Serina Ha's Pressed
Flower Exhibition /
Pressed Flower Workshop

雷頌德、夏妙然、鄭國江、高世章
Mark lui, Serina Ha, Cheng Kok Kong,
Leon Ko

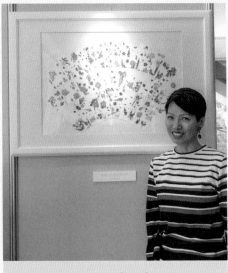

工作坊學員作品——押花書籤
Students' artwork - Pressed Flower Bookmark

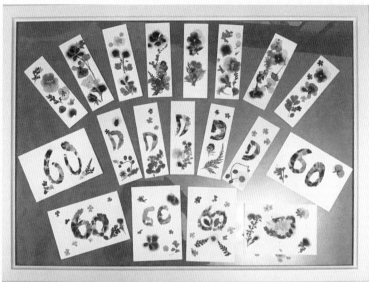

陳百強國際歌迷會工作坊
Danny Chan International Fan Club
Purple Memory of Danny Chan Pressed Flower Workshop

# *14*

## 你是我的明燈、照亮我的人生
### You Light Up my Life

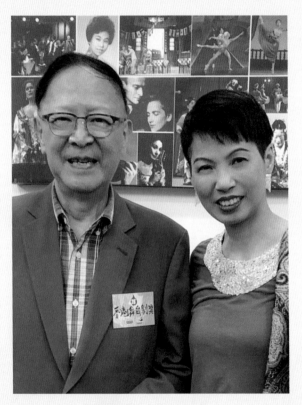

鍾景輝博士及夏妙然博士

鍾景輝博士：
　花藝優越　精彩人生　恭喜！

（鍾景輝）

賞花會友
My art for you

這作品代表我對鍾景輝博士 King sir 的敬意：
謹祝你身體健康

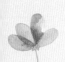

花的世界無限可能

夏妙然博士及李樂詩博士 （2018 年 12 月）
7-28/12/2018 夏妙然博士個人作品展（香港韓國文化院）
( Dr Serina Ha's Exhibition at Korean Cultural Centre in HK 7-28/12/2018)

　　在陽光之下，大自然有無窮的生命力；色彩；形態及香味。我們要懂得愛護大自然、除了觀賞外，更可以永恆留住最美麗的時刻。我知道夏妙然一直醉心日本押花藝術研究、對日本文化有充分認識、對色彩十分敏感。她一直與不同的朋友分享這一種藝術、幫助他們找尋自己的創作世界，淨化心靈。我十分欣賞她在這方面的發展、可以幫助大眾、享受大自然之美；尋找更美麗及健康的人生。

Nature has infinite vitality; color; shape and fragrance under the sun. We have to love nature, in addition to watch, but also treasure the eternal retention of the most beautiful moment. Serina Ha has been obsessed with Japanese art research and Japanese culture and has a full concept of color and design of pressed flower art. She often shares her art with many people and helps them to create their own art and obtain a purified world of their own. I totally support her art development as a botanic artist and her kindness to teach and help others to enjoy the beauty of nature.

李樂詩博士
極地科學工作者

Eternal Flower
I hope your wish comes true.

**賞花會友**
**My art for you**

李樂詩博士
在我人生的路途上
妳一直是我的明燈
不斷給我鼓勵及指引
感謝妳
這作品代表我對妳的敬意
祝妳身體健康

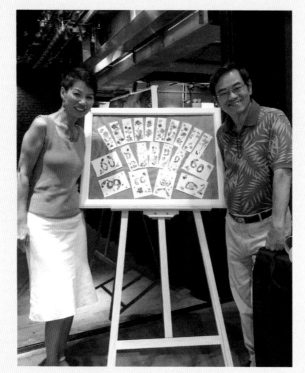

夏妙然博士及鄭國江老師

　　夏妙然要出一本有關押花藝術的專書，請我為她寫其中一篇序言。我在想，該怎樣去形容這女孩子？她是我任教小學時的學生，在我眼中，永遠是個孩子。看着她成長；學習和工作的成績；研習到專業的成就。過程中，肯定闖過一個個的難關。那仍專注的毅力，非一般女孩子可以練成的。想着想着，就「蕙質蘭心」去形容這孩子。

　　這孩子好學，因工作關係，要接觸不同的語言的歌，她就狠下決心，把英語、漢語和日語都學出好成績來。而且學習的成果，成為她押花藝術上的一大助力。除了幫助她修習這門藝術外，更為她鋪出美麗的道路，讓她在世界上不同的地域成功地展示她獨特且過人的作品，從而獲得驕人的成績和獎項。

　　難得的是這孩子以發揚押花藝術為己任。把所學所成與同好和後學分享。不以所學所言自誇，反而在不同的地域開班授徒，親自教授學生，還惠及有不同障礙的人仕。教授技術外，更為他們開展覽，為推廣押花藝術不遺餘力。

　　謹祝妙然押花藝術方面的技術和成就更上一層樓。

榮譽院士　鄭國江

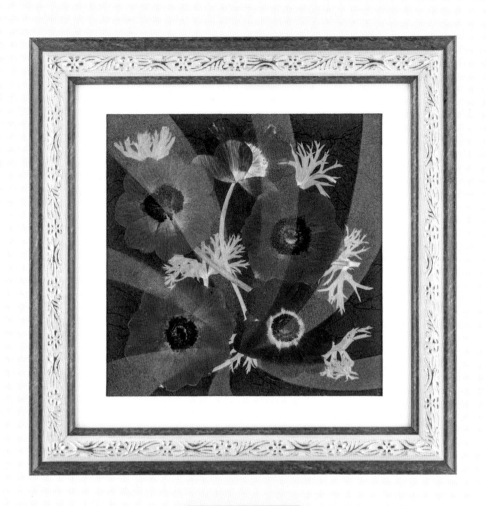

**賞花會友**
**My art for you**

鄭國江老師
你的作品一直陪伴我們成長
也給我們很多啟發
我更幸運的是
你是我小學老師
這麼多年從你身上學習
我可以為自己創造更多可能
你更是我藝術路上的明燈
我謹以這燦爛多彩的作品
祝鄭老師及鄭太身體健康

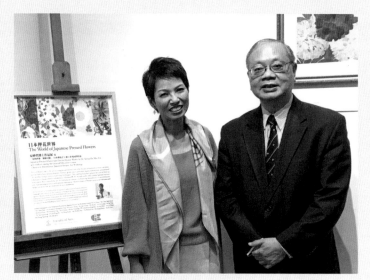

夏妙然博士及李焯芬教授

　　押花藝術源遠流長。早在十九世紀的維多利亞女皇時代，平面押花已十分流行。女皇本人就是一位押花高手，曾親自為王子洗禮的邀請函配上她自己設計的押花。押花是當時皇家和上流社會的一種流行的藝術活動。二十世紀中葉，出生於美國費城的著名影星、摩洛哥皇妃 Grace Kelly 亦是有名的押花大師。她親自設計了許多漂亮的押花畫，至今仍然有不少作品被珍藏。二戰以後，押花藝術傳入日本，廣受歡迎，不久即成為跟插花藝術相同等級的全國性藝術。今天，日本已是押花藝術最流行、最成熟的一個國家，湧現了許多知名的押花藝術家和押花世家。

　　本書作者夏妙然博士是香港大學的傑出校友之一，主修日本文化研究。她長期服務於香港電台，曾獲頒授十一個國際廣播獎。夏博士同時亦是日本全國押花及麗乾花導師，作品經常在世界各地展出，廣受稱賞，獲獎無數。本書結集了她多年來從事押花藝術義務教學的心得，包括學員們的迴響和反饋。當然，書中也展示了她的一些作品，同時能教會大家如何製作較簡易的押花藝術作品；內容可謂十分豐富。

　　押花藝術能提升人的專注能力。在繁忙的現代生活中，押花藝術又能幫助我們減壓；既怡情又能帶來不少的正能量，因此越來越受到社會各界的歡迎。夏博士作為一位資深和優秀的押花導師，多年來為我們的社區組織培育了大量的藝術人才，輸送了不少的歡樂與正能量，讓我由衷的讚嘆和敬佩。

<div align="right">

李焯芬
香港大學前副校長
饒宗頤學術館館長

</div>

　　As an art form, pressed flower has a long history.　It became quite popular in the nineteen century, during the reign of Queen Victoria.　The Queen herself is an expert in this art.　She made the pressed flower design for the invitation cards, on the occasion of the baptism ceremony of her prince.　It was a common art form for the royal family and the elite at the time.　By the mid-20th century, the legendary movie star and princess of Monaco, Grace Kelly, was also well known for her masterpieces of pressed flower, which are still being treasured today.　After the Second World War, this art form became extremely popular in Japan, and is now at par with the art of Japanese floral arrangement. Over the years, numerous masterpieces of pressed flower emerged in Japan, along with many well-known family enterprises in pressed flower.

A distinguished alumnus of the University of Hong Kong, Dr. Serina Ha is also well known for her achievements and teaching in the art of pressed flower. Her undergraduate major and the focus of her doctoral research are both Japanese cultural studies. She has an eminent career with Radio Television Hong Kong, and is the recipient of eleven international broadcasting awards. At her spare time, she serves as a certificated teacher for the arts of pressed flower and L'écrin flower. Her masterpieces are often showcased in exhibitions worldwide, receiving acclamation and numerous awards over the years. This new book of hers consolidates her dedicated work and marvellous achievements in this regard. It features some of her masterpieces, her instructions on pressed flower creation, and feedbacks from her students.

As an art form, pressed flower can help to develop our concentration span. It helps to reduce stress in today's pressure-cooker life. It is therefore a valuable means of stress control, and a source of positive energy in life. This explains its increasing popularity in our society. We are extremely grateful to Dr. Ha for her remarkable contributions in sharing this art form with numerous NGO's and groups in need over the years. We do hope that she would dedicate more time and energy to the propagation of this important art form in the years ahead.

<div align="right">

C.F. Lee, GBS, SBS, JP<br>
Professor Emeritus and former Pro-Vice-Chancellor,<br>
Director, Jao Tsung-I Petite Ecole,<br>
The University of Hong Kong

</div>

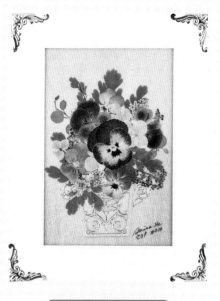

賞花會友
My art for you

李煇芬教授
一直得到你的支持和鼓勵
無言感激
謹以這作品
祝教授及家人身體健康

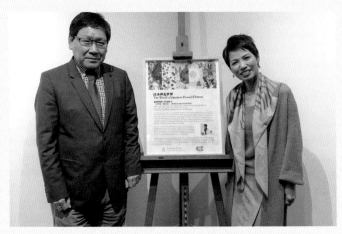

方梓勳教授及夏妙然博士

## 活在當下的妙然

　　春節來臨之際，我去大埔墟買了幾枝應節的百合花。今天是年初四，剛好有數朵花兒盛開，手掌那麼大，淡紫紅色的，非常驕人地展露著他們的笑容，旁邊還有不少含苞待放的花蕾陪伴着，加上碧綠茁壯的葉子，毫不羞澀地告訴我們，這個世界多麼美好！百合花誠然耐放，但過了一個星期左右總會枯萎，不能逃過被人遺棄在垃圾堆的命運。花開花落，雲舒雲卷，只要寵辱不驚，去留無意，自當無須介懷。但我們這一輩份的人，總不免緬懷過去，青少年時代的花樣年華，逝去不返，時光永駐自是沒有希望的希望。

　　唐人杜秋娘詩句有云：「花開堪折直須折，莫待無花空折枝。」這當然是「勸君惜取少年時」的勵志之言，但能夠做到超越和戰勝「無花空折枝」的困境的，就是我的朋友押花藝術家夏妙然博士。在她創造的押花世界裏，永遠都是姹紫嫣紅，花團錦簇，直把時間留住，鎖住了青春，保存著世界的美，是對於永續生命豐富和完美的擁有。

　　且讓我戲言一句：花開堪押直須押。好一個永恆的一剎那燦爛，好一個活在當下的妙然。

香港恒生大學翻譯學院院長
方梓勳

## Changeless Flowers

　　Eternality or impermanence? It depends on your point of view. Things are always becoming, never being.

　　Of all nature's gifts to us, flowers can be the most beautiful, but they are also ephemeral, usually lasting only a few days. In literature, they have become the habitual symbol of evanescence. The Cavalier poet Robert Herrick wrote in his To the Virgins, to Make Much of Time:

Gather ye rosebuds while ye may,

Old Time is still a-flying:

Coincidentally, the Tang Dynasty poetess Du Qiuniang also wrote in her famous poem Gold Threaded Dress:

Blossoming flowers, pick them while in bloom,

Tarry, you'll pick an empty branch in gloom!

(Adapted from a translation by Frank Yue.)

In both poems, flowers (falling) and time (flying) are the two common motifs, which are intertwined and interacting. Flowers are beautiful, but you have to enjoy them in time. They're here today, and gone tomorrow. Carpe diem, or seize the day. Presence and absence neatly make up a nice binary opposition.

Buddhism advocates impermanence, i.e., Wuchang, literally meaning "no always". Thus it values non-detachment. In the West, there is only the eternality of God; everything else is transitional. When one has to experience matters and things with time, and time is constantly changing, there cannot be changelessness.

Our friend Serina is a consummate master in the art of pressed flowers. In her many exquisite creations, many of which are award-winning works, she manages to preserve the fleeting beauty of flowers in their splendour, sometimes in their original form, and sometimes in exquisite re-arrangements of her original design. She is able to forestall the lamentation of transience in Robert Herrick and Du Qiuniang's poems, holding time in abeyance. Bingo! Beauty preserved: permanence arises from impermanence. In our age of instability, her pressed flowers offer us comforting constancy in a world which feels increasingly precarious.

Serina's artistry and creations have given us much pleasure over the years. I'm delighted that she has published a book of her collection of pressed flowers. I'm sure that it will similarly bring joy, wonder, pleasure and, above all, a sense of quietude in our noise-infested society.

<div style="text-align: right">

**Professor Gilbert C F Fong, MH**
Dean, School of Translation
The Hang Seng University of Hong Kong

</div>

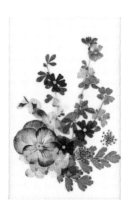

賞花會友
My art for you

方梓勳教授
一直得到你的支持和鼓勵
萬分感激
謹以這作品
祝教授及家人身體健康

花的世界無限可能

## 定格美好　傳播真情

　　之前「押花」對於我來說是一個很陌生的名詞，是學生夏妙然帶我進入了押花世界，稍加觀察，押花藝術就存在於生活中，同每個人都有千絲萬縷的關聯。

　　認識夏妙然是 2004 年她在香港浸會大學讀傳理學院碩士的時候。自幼在其父親的潛移默化下，夏妙然萌發了想去日本的念頭，立志要學好日文。日後，她漸漸地熱衷於學習日本文化、茶道、和服禮儀、日本押花藝術。特別在押花藝術上造詣頗深。

　　這部作品集，展現了她多年來的孜孜不倦追求押花藝術所取得成就，在國際押花藝術創作比賽中，她取得了多項榮譽和獎項，成績斐然。

　　多年來，她在不同的社福機構及學校教學，擔任藝術顧問，言傳身教，與學員交流技藝與心得，廣受歡迎。

　　夏妙然利用大自然的植物花草作為素材，巧妙地將其定格於瞬間，經過創作構思和藝術設計，又賦予其新的生命，其押花作品，時而艷美，時而精細，時而靈動，時而恬靜，斑斕多姿，令人讚歎。

　　她的作品不單給人予美的享受，而且在當前的香港社會環境中，亦有著特殊的審美意蘊：這種凝固嬌麗的藝術將喚起人們淡定包容的心態並勇於面對生活中的困境與挑戰，同時對認知障礙症患者更有特殊的情感意義。

<div align="right">

黃煜教授
香港浸會大學傳理學院院長

</div>

**賞花會友**
**My art for you**

<div align="center">

黃煜教授
感謝你當年在我進修浸大傳理學院碩士課程開始
一直給我支持和鼓勵
萬分感激
謹以這作品
祝教授及家人身體健康

</div>

## 將短暫變為永恆

　　再美的鮮花總有凋謝的一天。經過押花創作者的精巧構思，將花朵定格於最自然美麗的一刻，就可以變成一件獨一無二的藝術品，賦上了新的生命意義。

　　押花是一門藝術，也是消遣、減壓活動，亦是親子活動。在製作押花的過程中，暫時拋開煩惱，專注於創作專屬自己的作品；看着美麗的製成品，心靈得以療癒。

　　我認識押花藝術，始於本書作者夏妙然博士。她於日本研修日本押花藝術，是日本全國押花藝術協會押花、麗乾花及夢想花導師，作品屢獲殊榮，經常在不同地方展出。夏博士一直積極推廣押花藝術，她著書立說，教導簡易的押花製作方法外，又透過自己作品分享多年來從事義務教學的心得。我衷心祝賀她「雙喜臨門」：大作準備付梓之際，又勇奪「美國費城全國花展」（2020 Philadelphia Flower Show）押花項目冠軍，為港爭光。押花有助淨化與療癒心靈，對今天的香港另有一番特殊意義。押花將短暫變為永恆，令這種藝術添上一份人生哲學味道，敬希讀者體會。

<div align="right">

李家駒博士
香港出版總會會長

</div>

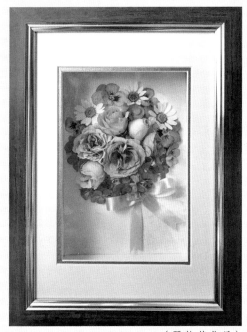

（麗乾花作品）

**賞花會友**
**My art for you**

李家駒博士
以此麗乾花作品
謹祝你生活愉快、身體健康
感謝你

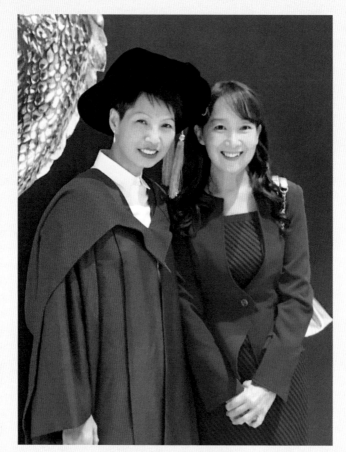

夏妙然博士及陳美齡博士
2017 年 12 月 2 日　香港大學（夏妙然博士畢業典禮）
Dr Serina Ha and Dr Agnes Chan
(The 199th Congregation of HKU on 2/12/2017)

　　夏妙然博士是一位努力上進的超級女強人。但她的押花作品表達出她溫柔和善良之心。

　　世上有她，是我們的福氣。

　　優しくって芯の強い素晴らしい女性です。

陳美齡博士

（麗乾花作品）

## 賞花會友
## My art for you

Agnes
妳從來是我的偶像
從日本文化
學術研修
生活百科
那種正能量
每一刻給我力量
向前

以這作品誠心祝福妳及家人身體健康

感謝妳

本當にありがとうじゃいます

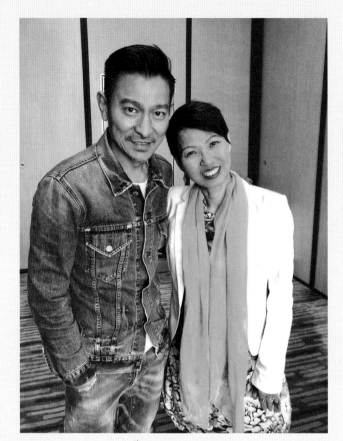

劉德華博士及夏妙然博士
Dr. Andy Lau & Dr. Serina Ha

無限可能

# 回憶中的路易斯湖（掃描篇）
## Memory of Lake Louise

**賞花會友**
**My art for you**

劉德華
我們一起走過的日子
彷如我的押花作品
回憶中的昨天
感謝你
支持我擁有
美麗的每一天
「無限可能」

高世章先生及夏妙然博士

Anyone who knows Serina, or Miu Miu as we affectionately call her, sees that she embraces life with full force. She is both an artist and an administrator, which means that she can set wild goals and achieve them. Her love of the Japanese culture is legendary. While most of us say we are familiar with Japan, few go beyond sushi, shopping in Ginza or taking pictures of red leaves in autumn. Serina's respect and appreciation of Japan deserve admiration. Her passion in oshibana has won her multiple international awards, sometimes over Japanese natives. She has a PhD in Japanese pop culture and she is venturing into floral arrangements and tea ceremony. Miu Miu has taught us a great lesson: Showing respect for others is showing respect for yourself. She is also incredibly tech savvy. She was the one who urged me into opening an Instagram account (I am not a fan of social media at all) and was ecstatic when I finally did.

She has a very strong sense of helping others and opening new worlds for them, all the while having fun and doing what she loves.

That is indeed the best way to change the world.

Leon Ko

（麗乾花作品）

賞花會友
My art for you

Leon
When you Say Nothing At All
Truly Thanks
Especially for you

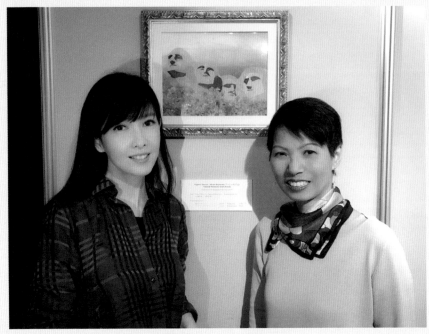

周慧敏小姐及夏妙然博士
Vivian Chow & Dr. Serina Ha

妙然自在

（周慧敏）

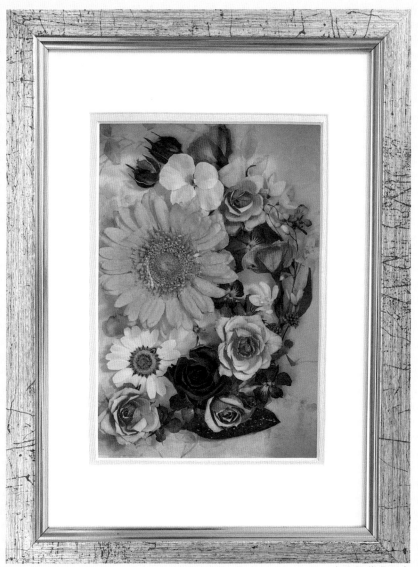

（麗乾花作品）

**賞花會友**
**My art for you**

Vivian
成長的日子
為你的一切而驕傲
感激你一直支持
讓我們繼續精彩人生！

花
的
世
界
無
限
可
能

<div align="center">柳生政一先生及夏妙然博士</div>

香港日本人商工會議所事務局長 柳生政一：

セリナ様　この度押し花の本を出版されると伺いお祝いも申し上げます。

2000 年から 2007 年まで香港大學の大學院で日本に関して
「現代の言葉と文化」をテーマに日本について深く研究された伺っています。
　その過程で多くの文化分野、例えば生け花、和服の著付け、日本舞踊などを極められました。
　日本の女性よりも日本らしさを持ちです。お會いする度に日本文化への造詣の深さと優雅さに圧倒されます。

　なかでも「押し花」に注ぐ愛情は並大抵のレベルではありません。
　最近お會いした時に語られた「芸術と心の癒し」を持つ二面性を待つ「押し花」にまつわるお言葉は、私の心に深
く刻まれています。
　美しい花を永遠の世界に誘う作品の數々は、地球の環境に優しくまた長く人々の心を確かに癒してくれます。
　作品を拝見する度に、私の心に暖かさが生まれます。

　集大成の作品を読者の皆様がご覧になりページ毎に誘い込まれる姿を想像しています。
　ビジネスの世界に身を置く私ですが、今後も作品の數々を拝見し自身の心を癒しさせてください。
　更に創作活動に邁進されることを祈念申し上げます。

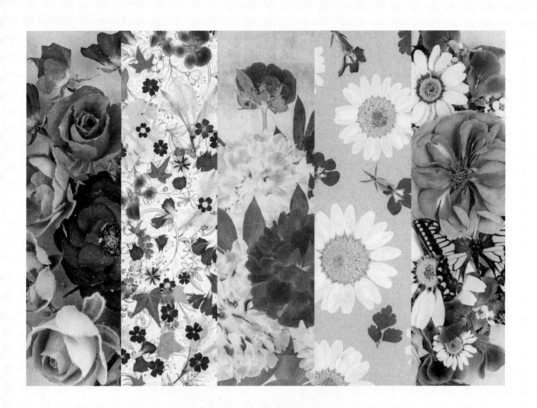

**賞花會友**
My art for you

政一先生
本当にありがとうごじゃいます

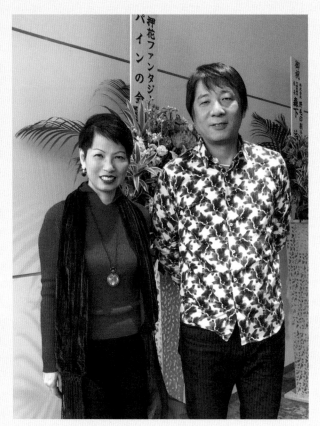

夏妙然博士及杉野宣雄先生

世界押花芸術協會會長 杉野宣雄：

このたび夏先生が作品集をご出版されましたこと、誠におめでとうございます。

夏先生には押し花やレカンフラワー、ネイチャープリント、ドリームフラワーなど、私が提唱する花のアートクラフトの世界「ボタニックアート」にいつもご参加いただき、大変感謝しております。

植物を自然の美しい色のまま乾燥させ、その乾燥させた植物の美しい色を長く保たせるという私の押し花の技術をもとに、私がレカンフラワーを創造し、発表したのは、２００６年の東京での個展のことでした。レカンフラワーは人工的に着色させたプリザーブドフラワーとは全く異なる、畫期的なドライフラワーとして大きな注目を集め、その魅力は日本から臺灣、香港へと広がりました。

「レカン」はフランス語で「寶石箱」という意味です。漢字では麗しい乾燥花ということで、「麗乾花」という字を當てました。その名の通りレカンフラワーは１０年以上経った今でも、寶石のように麗しい花として輝き続けております。香港で、夏先生が麗乾花などを楽しんでくださっていることは、本當に嬉しい限りです。

夏先生が今後もお元気で活躍され、ボタニックアートの輪を広げていってくださることを心から願っております。

世界押花芸術協會會長、ふしぎな花倶楽部會長
レカンフラワー協會會長、花と緑の研究所代表
杉野宣雄

杉野先生
本当にありがとうごじゃいます

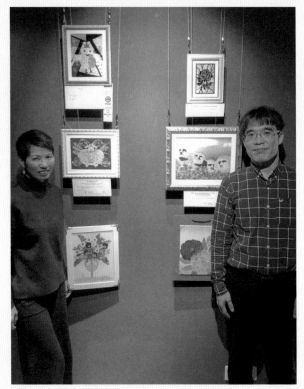

夏妙然博士及 Mr Park Jongtaek（朴宗澤先生）

7-28/12/2018　夏妙然博士個人作品展（香港韓國文化院）
( Dr Serina Ha's Exhibition at Korean Cultural Centre in HK on 7-28/12/2018)

駐香港韓國文化院 院長朴宗澤：
사랑이 듬뿍 담긴 멋진 예술 (art Book) 출판을 진심으로 축하드립니다 .
많은 사람들이 이 책을 통해 마음의 평온과 이웃 간의 사랑을 찾길 바랍니다 .
홍콩뿐만 아니라 전 세계 많은 분들이 이 책과 함께 하시 길 바랍니다 .
Congratulations on publishing this amazing art Book full of love.
I wish that many people find peace and love through this book.
Also, I hope people all over the world including Hong Kong will enjoy this book.

박종택 ( 朴宗澤 )
駐香港韓國文化院 院長
大韓民國駐香港總領事館
Mr Park Jongtaek
Director, Korean Cultural Center in Hong Kong,
Consul, Consulate General of the Republic of Korea in Hong Kong

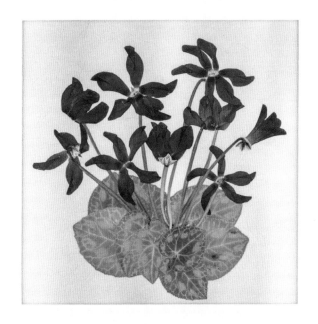

**賞花會友**
**My art for you**

朴宗澤先生
Thank you for your support

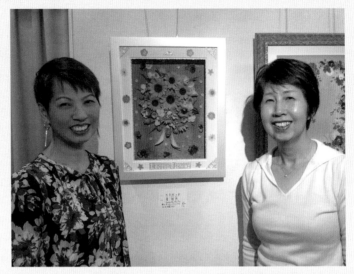

夏妙然博士及佐々木えみこ　Ms Emiko Sasaki

日本押花家 佐々木えみこ：

"セリナさんは日本の文化である押し花やレカンフラワーに興味を持たれ、遠く離れた日本で學ばれました。その色使いや構成はセリナさんの個性が表現され、とても素敵な作品ばかりです。

また、茶道、花道にも影響を受けられ、日本文化の間の取り方を総合的に身につけられています。

これからも花を愛し、素敵な作品を創作されることを希望します。"

Serina is so interested in the creation of Japanese pressed flower and L'écrin flowers that she decided to come to learn in Japan. The colors and composition of her art express Serina's personality, and her works are all very nice. In addition, Serina is fond of Chado and Ikebana (Japanese flower arrangement). She had obtained a comprehensive approach to Japanese culture. I hope she keeps on creating more wonderful works with her love of flowers.

（佐々木えみこ作品）

迷宮
Labyrinth
Ms Emiko Sasaki
佐々木えみこ
Outstanding Award
12th Japan L'écrin Flower Contest(2018)
第12回レカンフラワーコンテスト
優秀賞　受賞題名　ラビリンス

## 花材 Materials

**噴霧玫瑰**
Spray Rose
スプレー バラ
스프레이 로즈
Rose Vaporisateur

**紫羅蘭**
Matthiola incana
ストック
비단향꽃무
Matthiola incana Garten-Levkoje

**納麗石蒜屬**
Nerine
ネリネ
네리네
Guernseylilien Nerine

**小町藤**
Hardenbergia
ハーデンベルギア
하덴버지아
Harden Bengia Hardenbergia

陳曉東及夏妙然博士

春意凝望
春意漸濃「櫻」繽紛，
風吹滿頭許桃花。
凝眸一花風雅，
望春看日出日落。

美人遙憶鳳城西，芳草年年路欲迷。（明代：碩䇏）
誰畫誰容顏，誰寫誰眷戀？
一樹桃花一樹詩，
千樹花語為誰癡？

祝福夏妙然博士：
出書成功！
「畫從書出，書以畫入」。
事事如願日子甜！

（陳曉東）

**賞花會友**
My art for you

陳曉東
幾分鐘的約會
盼望的緣份
今天你「凝望」這「漣漪玫瑰」配上詩
十分有意思
祝願你一切順利
我們一起推廣——音樂 藝術 教育

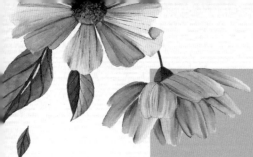

# 15

## 齊齊學押花
### Join Along to Create
### Pressed Flower Art with me

---

## 押花賀卡
### Pressed Flower Greeting Card

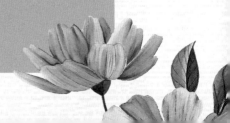

# I. 押花賀卡
## Pressed Flower Greeting Card

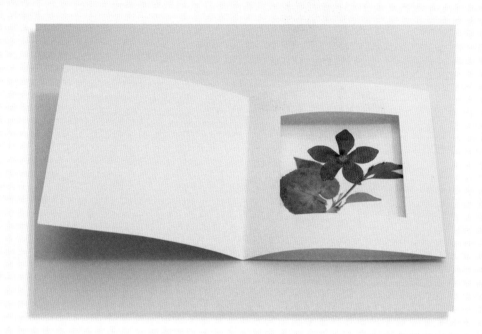

 所需材料 Materials - - - - - - - - - - - - - - - - - - - - - - - - - - - - - - - -

1. 白卡紙（15.5cm×15.5cm）
2. 小鉗子
3. 花材
4. 剝刀
5. 鉛筆
6. 膠紙（與白卡紙尺寸相同）

1. White cardstock (15.5 cm x 15.5 cm)
2. Tweezer
3. Flower material
4. Safety lock cutter
5. Pencil
6. Soft adhesive tape (same size as white cardstock)

準備一張白卡紙（15.5cm×
15.5cm），把它摺成三等份（摺
的方向按圖），再在中間剝出一
個洞（9.5cm×9.5cm）

Prepare a cardstock (15.5 cm x
15.5 cm), fold it into 3 parts (as
shown above)Use a safely cutter
to cut a rectangular hole (9.5 cm
x 9.5 cm)

把卡紙攤開

Spread the card and put it on the
table

用鉛筆沿四方形方格的四角（畫在底咭上）作底咭的範圍記號，再隨喜好設計圖案，把花材放到底卡紙上

Mark 4 edges by a pencil (according to the edges of the holes that have been cut) on the bottom page and place the flower material with design

把膠紙（15.5cm×15.5cm）準備好

Prepare a Soft Adhesive tape (15.5 cm x 15.5 cm)

**5**

把膠紙按比例輕放在花上
（留意步驟 6）

Gently place the Soft Adhesive
tape on top of the flower material
(As seen in Step 6.)

**6**

留意放下時先由中間按下，再用
手掌協助向四角按開推走空氣

Gently press down in the middle
and use the palm to help in
pressing the art outward to get rid
of the air

**7**

押花賀卡完成了！

Congratulations! You have created a lovely Pressed Flower Greeting Card!

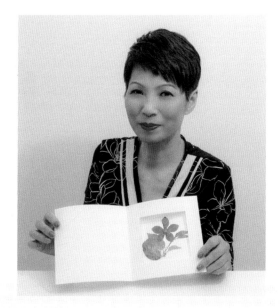

# 押花賀卡
## Pressed Flower Greeting Card

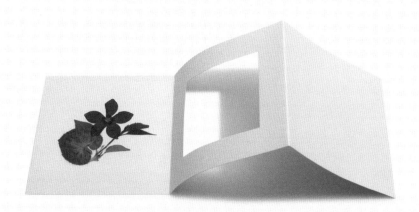

# II. 押花書籤
## Pressed Flower Bookmark

 所需材料 Materials ------------------------------------------

1. 白卡紙（15cm×5cm）
2. 和紙（同白卡紙尺寸相同，可在書局 / 美術用品公司買到）
3. 小鉗子（可在書局 / 美術用品公司買到）
4. 花材
5. 雙面膠紙（同白卡紙尺寸相同）
6. 漿糊

1. White cardstock (15 cm x 5 cm)
2. Washi - Traditional Japanese paper (same size as white cardstock)
3. Tweezer
4. Flower material
5. Double - sided adhesive tape (same size as white cardstock)
6. Paste

**1**

預備一張卡紙 15cm × 5cm 的白卡紙

Prepare a cardstock of size 15 cm x 5 cm

**2**

再預備一張相同大小的和紙

Prepare one Washi -Traditional Japanese paper (same size as Step 1.)

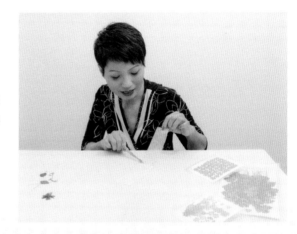

**3**

在卡紙上貼上雙面膠紙（膠紙要覆蓋整張卡紙），再把和紙的一邊輕輕貼上，闊度大約 1cm

Place the same size of the Double-sided adhesive tape on top of the cardstock (must cover the whole cardstock), and gently tape the Washi paper on one side (width about 1 cm)

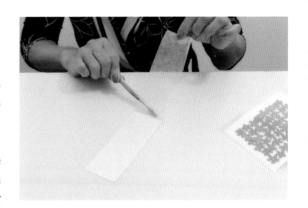

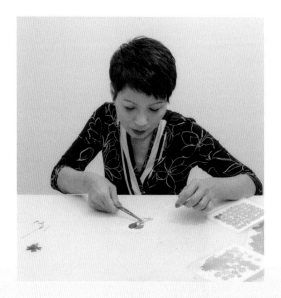

可先在一張白紙上用花材設計圖樣，再小心輕放在書籤上（輕放的原因是萬一要改變花材擺位，也可以再用小鉗子調整）

You can start to design your pattern on a sheet of white paper, then gently place the design on the bookmark (finalize the design by using the tweezer)

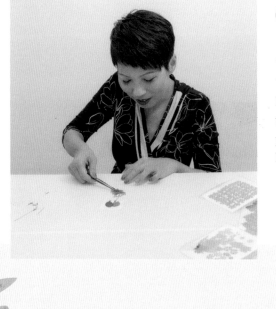

當用小鉗子把花材放到卡紙上的時候留意花材容易破爛，勿用手拿

Must be careful when placing the pressed flower with tweezer, please remember not to use your hand to pick the flowers

**6**

在完成的作品的花材上輕輕塗
上少量漿糊

Put little paste on top of the
Washi paper (on the flower part)

**7**

待乾後押花書簽完成了！（全乾
後，更可拿去過膠永久保存）

What a nice Pressed Flower
Bookmark !
( You can laminate it to keep it
forever)

# III. 押花筷子套
## Pressed Flower Chopstick holder

## 所需材料 Materials ----------------------------------

| | |
|---|---|
| 1. 顏色紙（26cm×12cm） | 1. Pink color paper (26 cm x 12 cm) |
| 2. 花材 | 2. Flower material |
| 3. 小鉗子 | 3. Tweezer |
| 4. 膠紙（5cm×5cm） | 4. Soft adhesive tape (5 cm x 5 cm) |

**1**

準備一張粉紅色顏色紙 (26cm×
12cm) ，把它摺成三部分，分別
為 4.5cm/4.5cm/3cm

Prepare a sheet of Pink color paper
(26 cm x 12 cm), fold it into 3 parts
(4.5 cm/4.5 cm/3 cm)

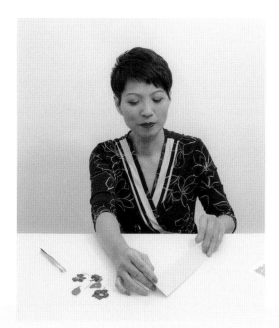

**2**

把顏色紙摺起來，3cm 的部分摺在
內，成為筷子套底部

Fold the smallest part (3 cm) inside
so it becomes the bottom of the
holder

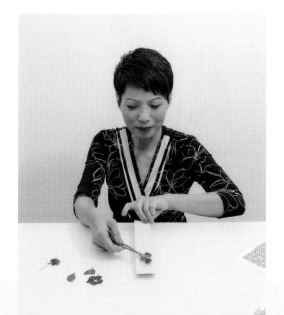

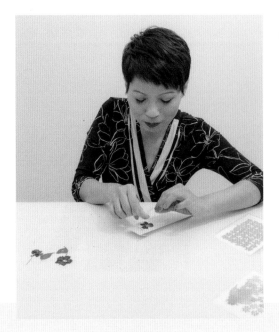

**3**

可先在一張白紙上用花材設計圖
樣。把筷子套反過來，在正面放
上花材，擺放花材的範圍要比膠
紙小（大約 3.5cm×3.5cm）

You can start to design the
pattern on a sheet of white paper,
then slightly place it on the front
of the folder. Please design only
3.5 cm x 3.5 cm and place it by
tweezer.

**4**

最後貼上膠紙（5cm×5cm），留
意要完全包圍花材部分，放下時
先由中間按下，再用手掌協助向
四角按開推走空氣，多餘的部分
可以同剪刀剪去。

Finally place the Soft Adhesive
tape (5 cm x 5 cm) on top of the
flower material. Gently press
down in the middle and use the
palm to help in pressing the art
outward to get rid of the air. You
can use a knife to cut away any
extra area on the sides if needed.

**5**

押花筷子套完成了！
What a wonderful Pressed Flower
chopstick holder!

有關此課齊齊學押花的內容或材料代購請電郵
oshibana888@gmail.com

或登入 www.oshibanaworld.com

Please email to oshibana888@gmail.com or
go to website: www.oshibanaworld.com
for any enquiry regarding this chapter

"Join Along to Create Pressed Flower Art with Me"

# 16

# 我的草月流世界
## My World of Sogetsu Ikebana

花的世界無限可能
在研修日本押花的同時
我亦是日本草月會會員
也藉這些作品鼓勵大家逆境自強
明天會更好
A Better Tomorrow

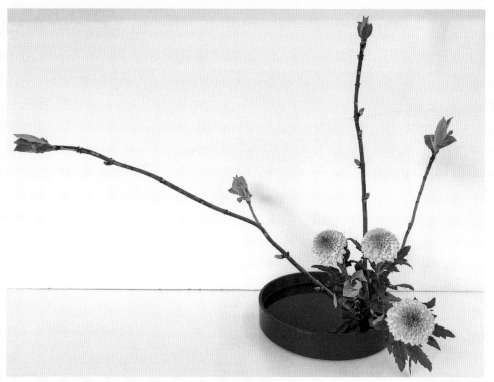

**歡欣的夢**
**Happy Dream**

-------------------------------- **花材 Materials** --------------------------------

菊
Chrysanthemum
菊
국화
Chrysanthème
Chrysantheme

繡球花
Hydrangea
アジサイ
수국
Hortensia
Hortensie

---------------- **容器：塑膠盤 Container: Plastic container** ----------------

菊花是 12 月的誕生花
原產地是中國
根據草月流的基本傾真型・盛花
Basic Slanting Style Moribana

三個主莖（真 Shin 45°副 Soe 15°控 Hikae 75°）中的
「真」的自然彎斜角度突顯作品風格
The Slanting Style of the Hydrangea macrophylla mainly determined
by the Shin (the main stem)

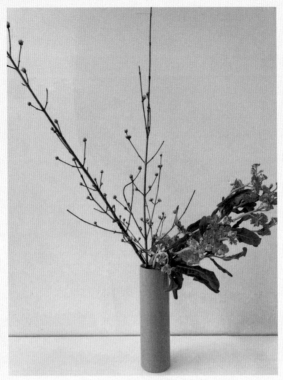

## 逆境自強
### Against all odds

------------------------------------ 花材 Materials ------------------------------------

**山茱萸**
Cornus officinalis
サンシュユ
산수유
Cornouiller
Japanische kornelkirsche

**粉紅羅蘭花**
Matthiola incana (hoary stock)
ビング ストック
핑크 난초
Grande giroflée
Garten-Levkoje

------- 容器：立式陶瓷花瓶 Container: Vertical Ceramic vase -------

羅蘭花起源自南歐，開花期為十一月至五月，花的顏色有紅色、粉紅色、白色、紫色、黃色等。羅蘭花 stock（ストック）有着「幹」的意思。在古希臘到羅馬時期經已出現，在日本鎖國年代由荷蘭的船隻運送到日本。因為它直長的外型、茂盛的花卉及誘人的香氣，常被用作花裝置的花材。另外，因它耐寒性強，從冬季到早春，它們都可以用作園藝材料

根據草月流的　基本傾真型‧投入（逆方向）
Basic Slanting Style Nagerie (in Reverse)
交叉十字木用作固定三個主莖（真 Shin 45°副 Soe 15°控 Hikae 75°）
Crossbar is used to fix three main stems (Shin Soe Hikae)

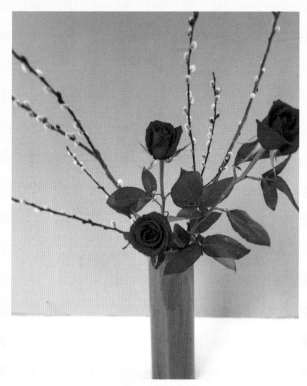

**艷紅玫瑰**
**Roses are Red**

---

## 花材 Materials

| 玫瑰 | 貓柳（銀柳） |
|------|------------|
| Rose | Salix gracilistyla |
| バラ | ネコヤナギ |
| 장미 | 갯버들 |
| Rose | Salix gracilistyla |
| Rose | Japanische Kätzchenweide |

---

## 容器：塑膠盤 Container: Plastic container

根據草月流的第一應用立真型・投入
Variation No.1 Upright Style Nagerie
第一応用立真型・投入
三個主莖（真 Shin 15°副 Soe 45°控 Hikae 75°）創建了
一個立體及有深度的空間
The impact of three dimensions must be shown with three main stems
(Shin Soe Hikae)

花
的
世
界
無
限
可
能

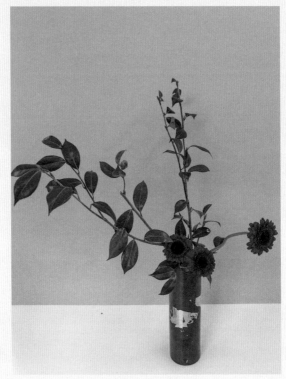

## 熱情洋溢
## Passion

-------------------------------- 花材 Materials --------------------------------

| 非洲菊 | 山茶花 |
|---|---|
| Gerbera | Camellia Japonica |
| ガーベラ | 椿 ツバキ |
| 거베라 | 동백 |
| Gerbera | Camélia japonais |
| Gerbera | Kamelie |

------- 容器：立式陶瓷花瓶 Container: Vertical Ceramic vase -------

根據草月流的第一應用傾真型·投入
Variation No.1 Slanting Style Nagerie
第一応用傾真型·投入
三個主莖（真 Shin 45°副 Soe 15°控 Hikae75°）其中真及副要
準確放置表現這特色
Shin and Soe must be positioned to present the style

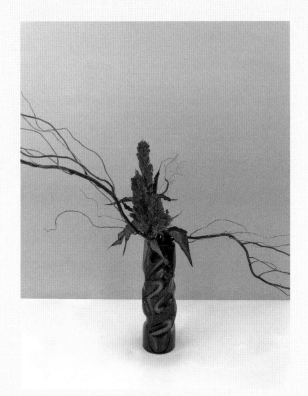

## 你是唯一
### Nobody But You

------------------------------- 花材 Materials -------------------------------

**青葙（野雞冠）**
Celosia argentea
ヤリケイトウ
청상자
Célosie argentée
Silber-Brandschopf

**雲竜柳**
Salix matsudana
ドラゴン柳
용버들
Saule tortueux
Korkenzieherweide

------- 容器：立式陶瓷花瓶 Container: Vertical Ceramic vase -------

根據草月流的第二應用傾真型・投入
Variation No.2 Slanting Style Nageire
第二応用傾真型・投入
三個主莖（真 Shin 45°副 Soe 75°控 Hikae 15°）中的「真」
和「副」的角度突顯作品的流線美及輕盈感
The chosen stems (Shin and Soe) can reflect linear style
and softness of the art

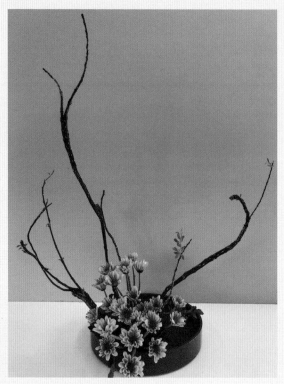

**粉紅女郎**
**Pink Lady**

-------------------------------- 花材 **Materials** --------------------------------

<div>

**粉紅菊**
Pink Chrysanthemum
キク
핑크 국화
Chrysanthème rose
Pink Chrysantheme

**柳**
Willow
やなぎ
버들
Saule
Weide

</div>

---------- **容器：塑膠盤 Container: Plastic container (Suiban)** ----------

根據草月流的第三應用立真型‧盛花
Variation No.3 Upright Style Moribana
第三応用傾真型‧盛花
兩個主莖（真 Shin 15° 副 Soe 45° 控 Hikae 75°）的線
必須完全不同
The lines of Shine and Soe must be different

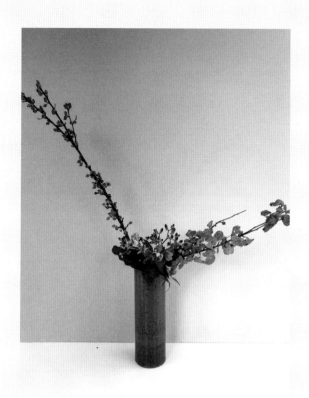

## 親親綠悠悠
### Green Green Grass of Home

---------------------------------- 花材 **Materials** ----------------------------------

| | |
|---|---|
| **山查子** | **杜鵑草** |
| Crataegus cuneata | Tricytis hirta |
| サンザシ | ホトトギス |
| 산사자 | 두견초 |
| Aubépine | Tricyrtis |
| Weißdorn | Krötenlilie |

------- 容器：立式陶瓷花瓶 **Container: Vertical Ceramic vase** -------

根據草月流的第三應用立真型・投入
Variation No.3 Upright Style Nagerie
第三应用傾真型・投入
排列的三個主莖（真 Shin 15°副 Soe 45°控 Hikae 75°）
創建了一個倒三角形的空間
The arranged three main stems (Shin Soe Hikae) created a reverse
triangle shaped space

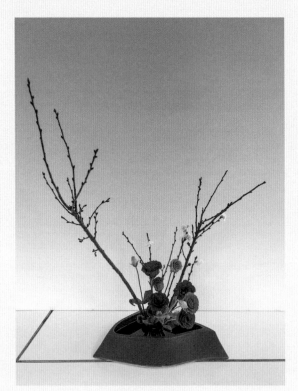

## 紫色人生
### Purple of my life

---------------------------------- 花材 Materials ----------------------------------

| 櫻花 | 洋桔梗 |
|------|--------|
| Cherry blossom | Lisianthus |
| サクラ | トルコキキョウ |
| 벚꽃 | 리시안셔스 |
| Fleur de cerisier | Lisianthus |
| Kirschblüte | Prärieenzian |

---------- 容器：塑膠盤 Container: Plastic container (Suiban) ----------

根據草月流的第三應用傾真型‧盛花
Variation No.3 Slanting Style Moribana
第三应用傾真型‧盛花
櫻花是春之花，生長地由日本沖繩到北海道、有 300 種不同種類，現代一般
在日本庭園的櫻花是染井吉野櫻花，對於普通家庭來說，會較多使用寒緋櫻
或山茶花等。
排列的三個主莖（真 Shin 45° 副 Soe 15° 控 Hikae 75°）
創建了一個倒三角形的空間
The arranged three main stems (Shin Soe Hikae) created a reverse triangle shaped space

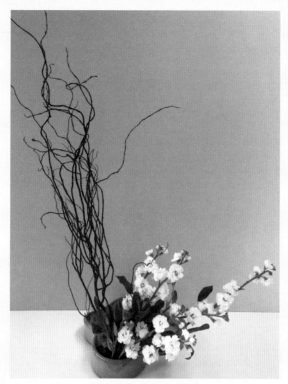

**有了你**
**Loving You**

------------------------------ **花材 Materials** ------------------------------

**白色紫羅蘭**                                    **紅染龍柳**
Matthiola incana (hoary stock)    Salix matsudana 'Tortuosa' (Red painted Dragon Willow)
白いストック                                  赤吹付ドラゴン柳
비단향꽃무                                       용버들
Giroflée blanche                                Saule tire-bouchon
Levkojen weiß                                   Korkenzieher-Weide

--------- **容器：大型陶瓷花瓶 Container: Huge Ceramic vase** ---------

根據草月流的第四應用立真型・盛花
Variation No.5 Upright Style Moribana
第四応用傾真型・盛花
白色紫羅蘭花起源自南歐十一月至五月開花期，花的顏色有紅色、粉紅色、
白色、紫色、黃色等。紅染龍柳與雲龍柳是同系但有不同。龍柳是雲龍柳的
一種變種，莖有黃色至紅棕色，其莖運動比雲龍柳的變化更大，柳樹的分支
的色澤，比雲龍柳更深，棕色更突出。留意兩個莖「真」和「控」
（真 Shin 15° 控 Hikae 75°）一高一低的藝術型態及創造出來的空間感。
Red painted Dragon Willow is a variant of the branch of Unryu willow. The color is
darker than Unryu willow and dark brown. Please carefully place the style and unity
of two stems (Shin and Hikae) and the space they created.

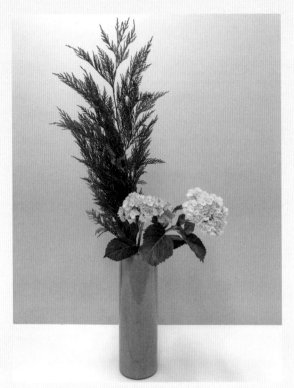

## 青青大自然
## Green in Nature

-------------------------------- 花材 Materials --------------------------------

| 繡球花 | 杉 |
|---|---|
| Hydrangea | Cyptomeria japonica |
| アジサイ | シギ |
| 수국 | 삼나무 |
| Hortensia | Cryptomeria japonica Japanische |
| Hortensie | sicheltanne |

------- 容器：立式陶瓷花瓶 Container: Vertical Ceramic vase -------

根據草月流的第四應用立真型・投入
Variation No.4 Upright Style Nagerie
第四応用傾真型・投入
觀察兩個莖「真」和「控」（真 Shin 15°控 Hikae 75°）
創造出來的空間感，如何跟其他配襯得更有層次感
Please be aware of the space which created by two stems
(Shin and Hikae)

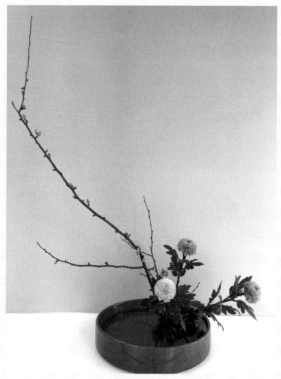

**為你鍾情**
**With you I'm born again**

---------------------------------- **花材 Materials** ----------------------------------

| | |
|---|---|
| **日本木瓜** | 菊 |
| Japanese quince | Chrysanthemum |
| ぼげ | 菊 |
| 명자나무 | 국화 |
| Cognassier du Japon | Chrysanthème |
| Japanische Zierquitte | Chrysantheme |

-------------- **容器：塑膠盤 Container: Plastic container** --------------

根據草月流的第四應用傾真型・盛花
Variation No.4 Slanting Style Moribana
第四応用傾真型・盛花
中間不同顏色的菊成了 2 個莖「真」和「控」
（真 Shin 45°控 Hikae 75°）創造出來的對比
The color contrast of one kiku flower for both two stems
(Shin and Hikae) with unity

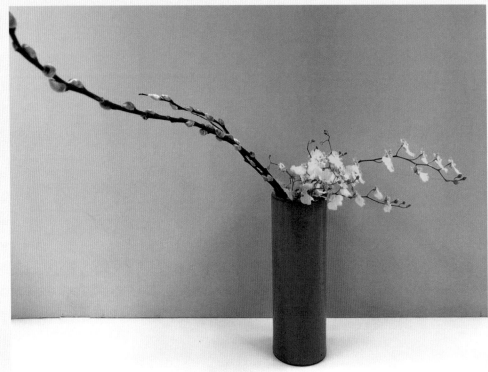

## 奔向陽光
### A bright Day

---------------------------------- 花材 Materials ----------------------------------

| | |
|---|---|
| **文心蘭** | **銀芽柳** |
| Oncidium | Salix x lecopithecai kimura |
| オンシジウム | キンメヤナギ（金芽柳） |
| 온시듐 | 은아류 |
| Oncidium | Chaton de saule |
| Oncidium | Weidenkätzchen (Salix caprea) |

-------- 容器：立式陶瓷花瓶 Container: Vertical Ceramic vase --------

根據草月流的 第四應用傾真型・投入
Variation No.4 Slanting Style Nageire
第四応用傾真型・投入
純用兩個莖「真」和「控」（真 Shin 45°控 Hikae 75°）
創造出來的彎曲對比美感
Purely create the slanting style of two stems
(Shin and Hikae) with beauty and harmony

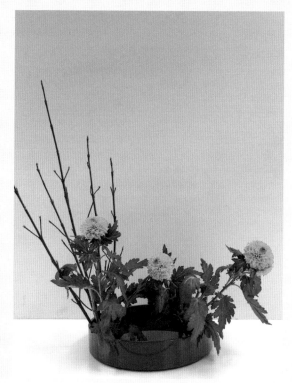

## 信自己
**My way**

---------------------------------- 花材 Materials ----------------------------------

菊
Chrysanthemum
菊
국화
Chrysanthème
Chrysantheme

珊瑚水木
Siberian dogwood
サンゴミズキ
흰말채나무
Cornouiller de Sibérie
Sibirischer Hartriegel

-------------- 容器：塑膠盤 Container: Plastic container --------------

根據草月流的第五應用立真型·盛花
Variation No.5 Upright Style Moribana
第五応用傾真型·盛花
觀察兩個主莖「真」和「副」（真 Shin 45°副 Soe 75°控 Hikae 15°）
的選材及放兩個針座（劍山）（けんざん）
用針座（劍山）來平衡兩個主莖。主莖中間的水位必須被看見
A pinholder (Kenzan) is used to balance the unity of 2 stems (Shin and Soe)
The water level between two stems must be seen.

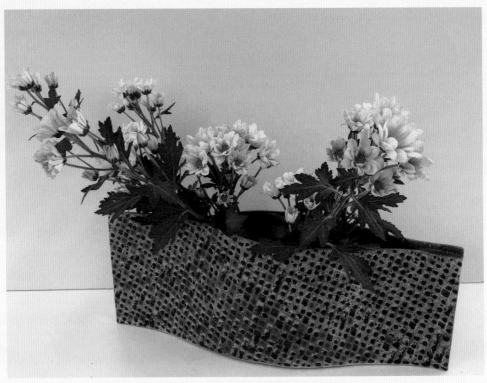

## 明天會更好
### A Better Tomorrow

---------------------------------- 花材 Materials ----------------------------------

菊
Chrysanthemum
菊
국화
Chrysanthème
Chrysantheme

--------- 容器：大型陶瓷花瓶 Container: Huge Ceramic vase ---------

根據草月流的 節日之花 - 特殊花材
Special Flower material for festival event
菊花為長壽的花用來慶祝九月九日重陽節
"A Free Style" for the celebration of
9th of September "Chrysanthemum Festival"

# 17

## 我的和裝世界
## My Kimono World

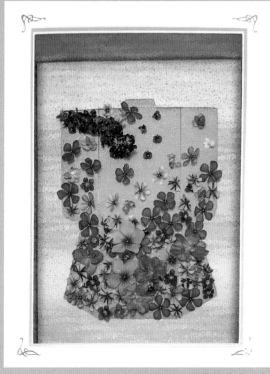

（麗乾花作品）

我只在乎你
Enchanting kimono - It Must be You
魅惑的な着物 - あなたが大好き
너만 위해서
Je ne pense qu'à toi
Ich interessiere mich für dich nur

------------------------- 花材 Materials -------------------------

| 千鳥草 | 長春花 | 小町藤 |
|---|---|---|
| Larkspur | Catharanthus roseus | Hardenbergia |
| チドリソウ | 日々草（ニチニチソウ） | ハーデンベルギア |
| 락스퍼 | 일일초 | 하덴버지아 |
| Pied-d'alouette | Pervenche de Madagascar | Harden Bengia |
| Rittersporn | Madagaskar-Immergrün | Hardenbergia |

| 繡球花 | 馬鞭草 | 紫芳草 |
|---|---|---|
| Hydrangea | Verbena | Exacum Affine |
| アジサイ | バーベナ | エキザカム |
| 수국 | 버베나 | 엑사쿰 |
| Hortensia | Verveine | Exacum Affine |
| Hortensie | Eisenkraut | Blaue Lieschen |

2020 年成為日本和裝教育協會認定的和裝二級講師

對日本和裝（和服）的喜愛

與日本茶道一樣 是那種優雅

是那種專注

啟發我的押花世界

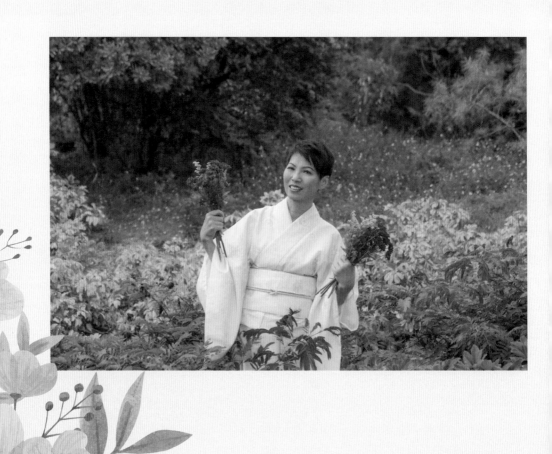

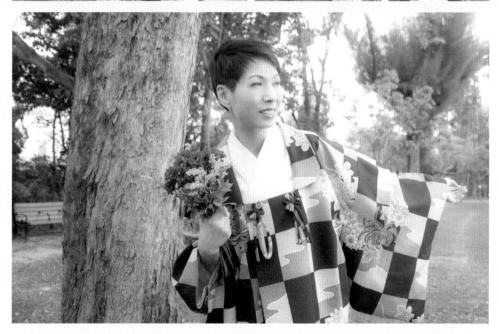

裏千家
Urasenke Chado

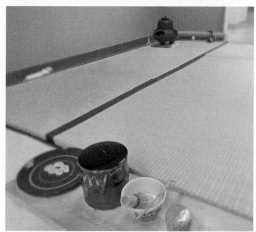

和敬清寂
一期一會
茶道精神

日本茶道傳播歷史悠久的
日本文化、也帶我們進入
治癒心靈的世界。

# 夏妙然博士 押花慈善展覽
## Dr. Serina Ha Miu Yin Pressed Flower Charity Exhibition

### 花的世界無限可能 - 愛地球
### Chances to Possibilities - Embrace The World

Exhibition period and Venue:
Details to be determined and announced soon.

Pressed flower craft is the art of using pressed flowers and botanical materials to create an entire picture from these natural elements. Flowers, petals, leaves and other organic materials are being pressed until dry and flat, using a variety of pressing techniques. This craft has long been practiced as an art form in China and in Japan, where it is known as Oshibana (押し花). As early as the 16th century, Samurai warriors were said to have studied the art of Oshibana as a means of enhancing their powers of concentration, and of promoting patience and harmony with nature. Princess Grace of Monaco also practiced Oshibana and helped promote the art of pressed flowers worldwide.

Dr. Serina Ha Miu Yin holds a Ph.D. in Japanese Studies from the School of Modern Languages and Cultures at the University of Hong Kong. She is an accomplished Japanese Botanic Artist, as well as a Pressed Flower and L'écrin Instructor of the Japan Fushigina Pressed Flower Association.

Her art was first recognized at the 9th World Pressed Flower Craft Exhibition in Goyang Korea back in 2015 and her works have been widely exhibited in Osaka, Tokyo, Philadelphia and Hong Kong over the years. Dr. Ha has held an exhibition of her work at HKU in March 2017, as well as in Hang Seng University of Hong Kong and the Korean Culture Centre in 2018.

She recently won the 1st Prize Award in the Philadelphia Flower Show 2020 after receiving the Honourable Mention Award in 2017. She has also been awarded the Best Art Award in L'écrin Flower Competition in Tokyo in 2017 and 2018. Her art has been acknowledged and helped raise fundings for the Intellectually Disabled Education and Advocacy League, and for the Morris Charity Initiative. This year she hopes to raise charity donation for the Polar Museum Foundation.

www.oshibanaworld.com

Oshibana888@gmail.com

pressedflower_world

Oshibana Pressed Flower W

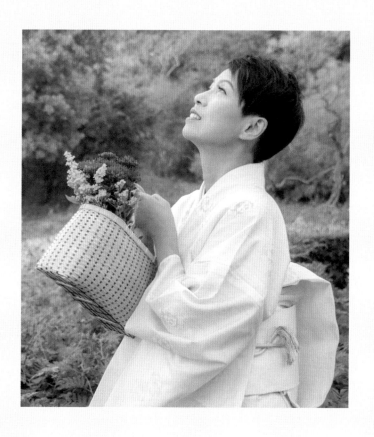

賞花治癒人生
Enhancing Life through Embracing Flower Art

逆境自強
Against All Odds

國際冠軍得獎作品
International Award

押花親子世界
Good Parenting Starts with Pressed flower

押花預防認知障礙症
How to Prevent Dementia

關注環保生態 / 啟發展能人士藝術興趣 / 鼓勵年青人藝術創作
Environmental Awareness/ Rehabilitation Program/ Encouraging Creativity

花
的
世
界
無
限
可
能

I would like to express my heartfelt gratitude to each and everyone of you who have contributed to the creation of this book.

Special thanks to my publishing team for making this book become a reality.

Let's continue to create more possibilities with the magic of flowers together.

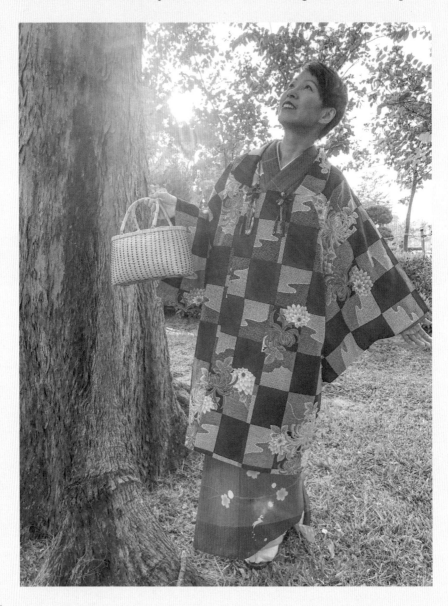

大波斯菊
Cosmos
コスモス

石斛蘭
Dendrobium
デンファレ

千鳥草
Larkspur
チドリソウ

小玫瑰
Mini Rose
ミニバラ

馬鞭草
Verbena
バーベナ

六出花（水仙百合）
Alstroemeria
アルストロメリア

白晶菊
Leucanthemum paludosum
ノースポール

常春藤
Hedera (Ivy)
アイビー

唐蒸草
Perillafrutescens
カラムシソウ

蕨類
Pteridophyta
シダ

鐵線蕨
Adiantum
アジアンタム

青木
Aucuba japonica
アオキ

飛燕草
Delphinium
デルフィニウム

小町藤
Hardenbergia
ハーデンベルギア

瓜葉菊
Cineraria
サイネリア

菫菜屬
Viola
ビオラ

星辰花
Limonium sinuatum
スターチ

石頭花
Gypsophila
かすみ草

# 花的世界無限可能
# Chances to Possibilities

賞花治癒人生
Enhancing Life through Embracing Flower Art

逆境自強
Against All Odds

# 帶你進入押花文化世界
# Welcome to the World of Pressed Flower

  （用手機掃描）

花的世界無限可能 I　　花的世界無限可能 II

Website: www.oshibanaworld.com
f Oshibana Pressed Flower World
✉ oshibana888@gmail.com
📷 pressedflower_world
📷 japaneseflower_ikebana
📷 chado80kimono

# 花 的世界 無限可能
## Chances to Possibilities

| | |
|---|---|
| 著者 | Author |
| 夏妙然博士 | Dr. Serina Ha Miu Yin |
| 責任編輯 | Project Editor |
| 李穎宜 | Wing Li |
| 裝幀設計 | Design |
| 李嘉怡 | Karie Li |
| 排版 | Typesetting |
| 辛紅梅、陳章力 | Cindy Xin, Chen Zhang Li |
| 資料統籌 | Data co-ordination |
| 夏妙然博士（日文） | Dr. Serina Ha Miu Yin (Japanese) |
| 資料搜集 | Data collection |
| 張穎研（韓文） | Cheung Wing Yin Winnie (Korean) |
| 蕭艷萍（德文） | Siu Yim Ping Penny (German) |
| Quentin Thomas（法文） | Quentin Thomas (French) |
| 攝影 | Photography |
| | All photos ©2020 Ha Miu Yin |
| 攝影監製 | Director |
| 夏妙然博士 | Dr. Serina Ha Miu Yin |
| 拍攝 | Shooting Team |
| 陳材偉（第15章及151頁） | Chan Choi Wai (Chapter 15 and Page 151) |
| 吳祉林 | Ng Tse Lam |
| 海報設計 | Poster Design |
| 李駿軒 | Li Chun Hin Justin |
| 出版者 | Publisher |
| 萬里機構出版有限公司 | Wan Li Book Company Limited |
| 香港北角英皇道499號 | 20/F, North Point Industrial Building, |
| 北角工業大廈20樓 | 499 King's Road, North Point, Hong Kong |
| 電話 | Tel: 2564 7511 |
| 傳真 | Fax: 2565 5539 |
| 電郵 | Email: info@wanlibk.com |
| 網址 | Web Site: http://www.wanlibk.com |
| | http://www.facebook.com/wanlibk |
| 發行者 | Distributor |
| 香港聯合書刊物流有限公司 | SUP Publishing Logistics (HK) Ltd. |
| 香港新界大埔汀麗路36號 | 3/F., C&C Building, 36 Ting Lai Road, |
| 中華商務印刷大廈3字樓 | Tai Po, N.T., Hong Kong |
| 電話 | Tel: 2150 2100 |
| 傳真 | Fax: 2407 3062 |
| 電郵 | Email: info@suplogistics.com.hk |
| 承印者 | Printer |
| 中華商務彩色印刷有限公司 | C & C Offset Printing Co., Ltd. |
| 規格 | Specifications |
| 特16開（240mm×170mm） | 16K (240mm×170mm) |
| 出版日期 | Publishing Date |
| 二零二零年六月第一次印刷 | First print in June 2020 |